D0501162

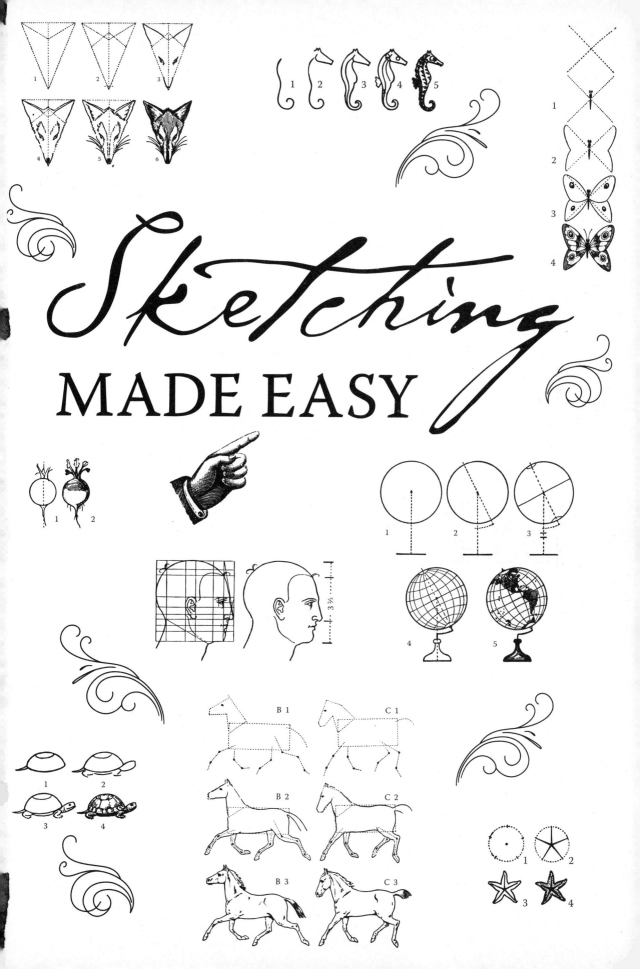

Sketching
MADE EASY

Follow us on social media!

Tag us and use #piccadillyinc in your posts
for a chance to win monthly prizes!

© 2017 Piccadilly (USA) Inc.

This edition published by Piccadilly (USA) Inc.

Piccadilly (USA) Inc.
12702 Via Cortina, Suite 203
Del Mar, CA 92014
USA

All rights reserved. No part of this publication may be reproduced, stored in a retrieval system,
or transmitted in any form or by any means, electronic, mechanical, photocopying, recording,
or otherwise, without prior consent of the publisher.

10 9 8 7 6 5 4 3 2 1

Printed in China

ISBN-13: 978-1-60863-455-2

 INTRODUCTION

If you have the inspiration but not the training, you've picked the right book. Every new skill begins with the fundamentals, a foundation on which to build. As it turns out, so do great sketches! If you can draw a line, a triangle, or a circle, you're ready to start. Using a strong base of simple, geometric shapes and lines, and plenty of space to practice, this book provides the tools you need to create beautiful, lifelike drawings.

Everyone is an artist with this beginner's guide to drawing and sketching. With lessons originally selected and updated from *Drawing Made Easy* (1921) and *Practical Drawing* (1915) by artist E.G. Lutz, this step-by-step process has given a century of emerging artists the techniques they need to bring their pictures to life.

The influence of cartoonist, E.G. Lutz, is well-known in the world of drawing and animation. In the early 1900s, his work appeared in major magazines like *The Monthly Illustrator*, *The World*, *Life*, *The Sun*, *The Washington Times*, and many others. Lutz also contributed to the world of art with more than a dozen books about drawing, animation, and motion pictures, including the two upon which this book is based.

Lutz's books groomed a generation of artists, including a struggling cartoonist who founded a now famous motion picture company. Before Walt Disney was a household name, his illustrations were rejected time and time again. After his service in WWII ended, he founded his own commercial art company, but this, too, was short-lived. That is, until he found Lutz's books at the Kansas City Public Library. Disney himself credited Lutz's lessons with taking his art to the next level, and Disney animators often mentioned using his books as references in the studio.

Whether you are a passionate hobbyist or an aspiring professional artist, if the tips in this book birthed what is now a billion-dollar industry, imagine where they may take you!

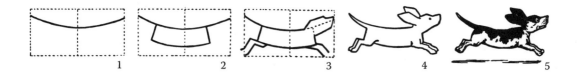

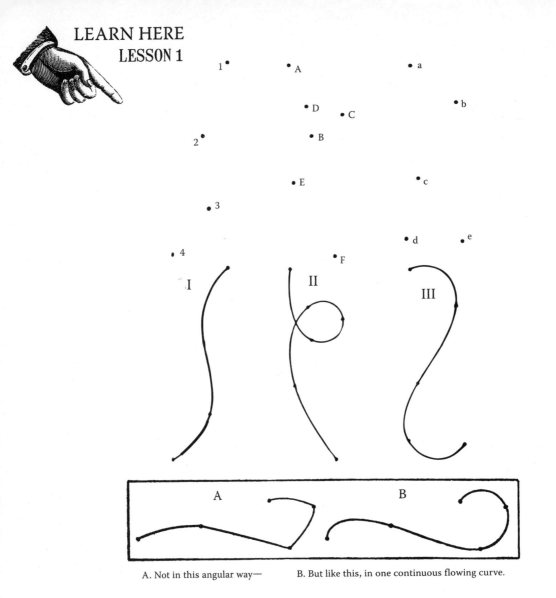

A. Not in this angular way— B. But like this, in one continuous flowing curve.

DRAWING CURVES WITH THE HELP OF A SERIES OF DOTS

It isn't always the color that attracts our attention in beautiful objects—it's their form or outline. For instance, in a vase the curving form is as beautiful as the color. In flowers, leaves and shells, the outlines that define the shape delight the eye.

The diagrams on this page are suggested drawing exercises to help you appreciate the beauty in lines as well as emphasize the importance of thinking while drawing.

Make a series of scattered dots as shown. Be sure the dots are different distances apart. Now, if we take the first example, with the dots marked, 1, 2, 3, and 4: we start our line at the 1st dot, continue it to the 2nd, and then to the 3rd, and ending at the 4th. The idea is to make an easy flowing curved line from the first dot to the last. There must be no break or angular turning. Try to forget the pencil-point, and imagine a curved line already marked on the paper going through the dots.

If you keep your eye on the pencil and watch it as you draw—the wrong way—the line will be like Diagram A above, angular instead of beautiful.

PRACTICE HERE

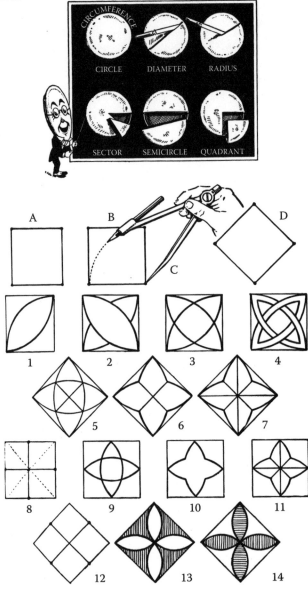

MAKING DESIGNS BASED ON A SQUARE
WITH THE HELP OF THE COMPASS

Some impressive things about geometry are explained above, you now know the different parts of a circle.

The first step to making the bottom image designs is to construct a square with a ruler and a triangle. With the ruler, measure what will be the sides of the square to equal length, and with the triangle get the four corners to each be an exact right-angle.

The first seven designs are made by placing the point of the compass in the corners, as in B. In Figure 9 you have four other points to set your compass and draw more designs. (Turn back to this page again later to look at the picture and be reminded of the meaning of "radius" and "circumference.")

PRACTICE HERE

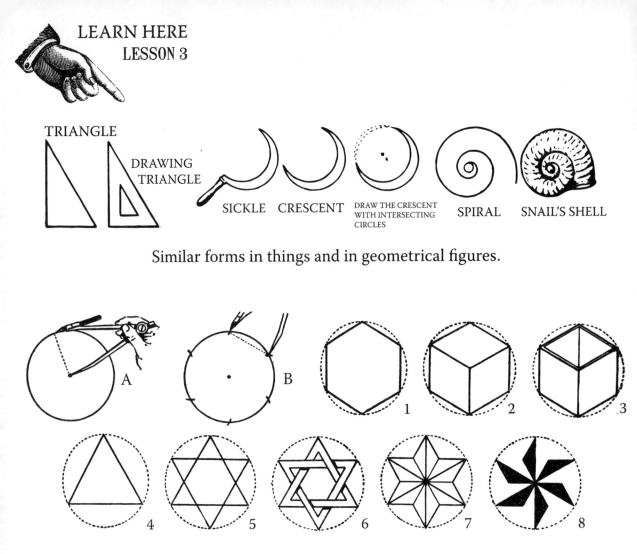

TRIANGLE

DRAWING TRIANGLE

SICKLE CRESCENT DRAW THE CRESCENT WITH INTERSECTING CIRCLES SPIRAL SNAIL'S SHELL

Similar forms in things and in geometrical figures.

A B 1 2 3

4 5 6 7 8

DRAWING DESIGNS WITH THE COMPASS AND WITH A CIRCLE AS A FOUNDATION

Draw a circle with the pencil compass as shown in A on this page. When you have completed the circle, keep the legs of the compass at the same distance apart as they were for the circle. Mark around the circumference of the circle, which the compass will go around exactly six times as shown in B.

This dividing of a circle into six parts by marking the radius on its circumference is an unalterable law, and if you find that it does not come out this way on your first attempt, it simply means that you must try again. When you have drawn a number of circles and worked carefully in getting the points equally marked, you will have foundations for drawing the figures and designs on the rest of this page. Figure 1 is a hexagon, or six-sided plane, while Figure 4 is a triangle, or plane with three angles and three sides.

These designs, as well as those on the previous page, made within a square, may be brightened up by coloring with crayons.

PRACTICE HERE

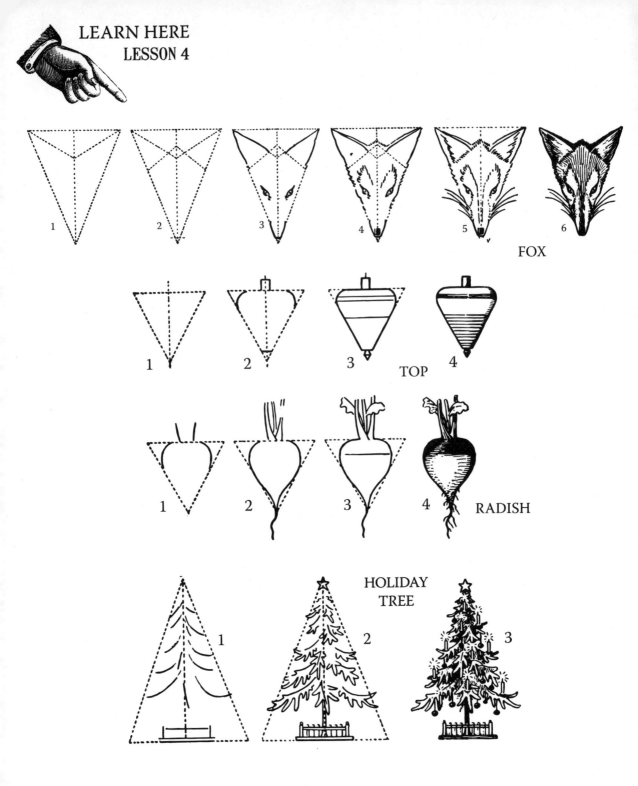

FOX

TOP

RADISH

HOLIDAY
TREE

FOX, TOP, RADISH AND HOLIDAY TREE

The first thing in drawing is to understand the subject's form. Some objects are so oddly formed and full of detail that we must stop and take a few minutes to study their form and the meaning of the detail. But there are other things of simpler form that are easier to draw. The pictures on this page, for instance. It is easy to see that their general outlines are made up by triangles. If a triangle is drawn, as indicated in the first figure of each example, the rest of the drawing can then be drawn as well.

PRACTICE HERE

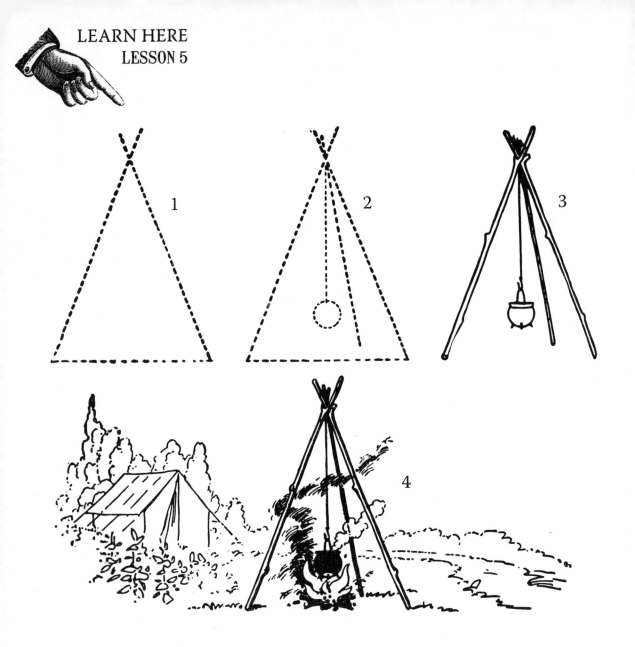

CAMP FIRE

Here are two more subjects, one on this page and the other on the following, that are very easy to draw if we begin with their characteristic forms—triangles.

You don't have to copy the dotted lines in the images provided as dotted lines in your practice. Dotted lines in these examples, and in the diagrams throughout the book, merely represent construction lines that are to be marked faintly.

In going on with your drawing by following the lesson as indicated above, always keep constantly in mind that it is the completed sketch, as in Figure 4, that you are endeavoring to copy.

PRACTICE HERE

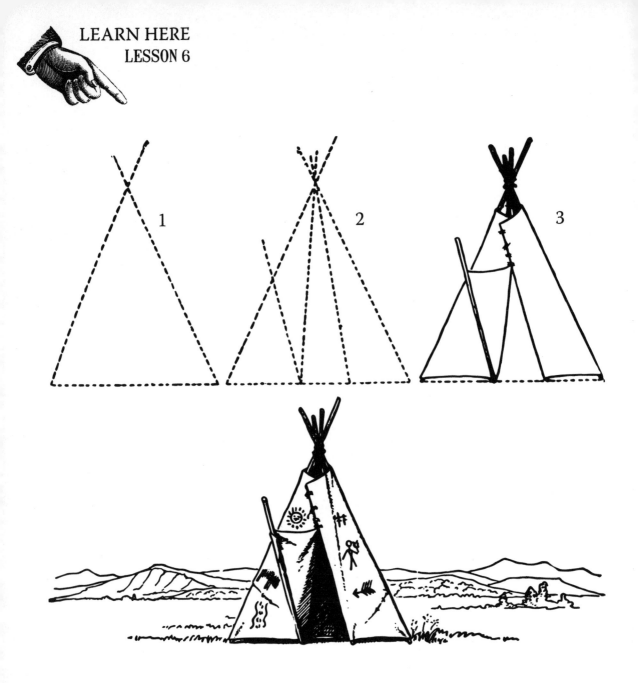

1 2 3

TENT

The tent shown above has a clear, triangular outline.

The construction lines, which you will mark faintly as suggested on the previous page, do not need to be erased in completing the sketch. When you have copied the landscape, place in the distance horses or a buffalo. Farther on in the book are lessons showing you how to draw these types of subjects. You will notice, of course, that the flap of the tent and the opening are both triangular.

PRACTICE HERE

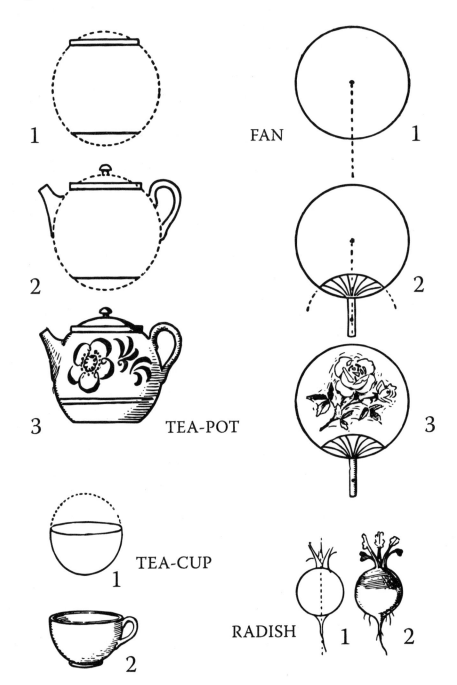

1 FAN 1

2 2

3 TEA-POT 3

TEA-CUP

1

2

RADISH 1 2

CIRCLES

Circles are used to start the subjects on this page. Where the form is clearly a circle, for example the fish bowl, use the compass. However, when drawing the cherries, the toy dog, or the radish, draw the circles free-hand.

PRACTICE HERE

GLASS FISH BOWL

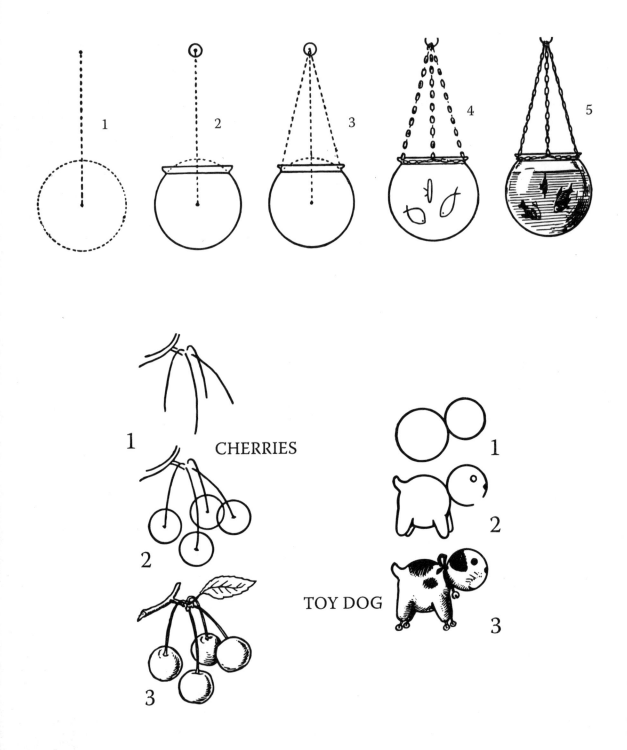

1
2
3
4
5

1
CHERRIES
2
3

1
2
TOY DOG
3

PRACTICE HERE

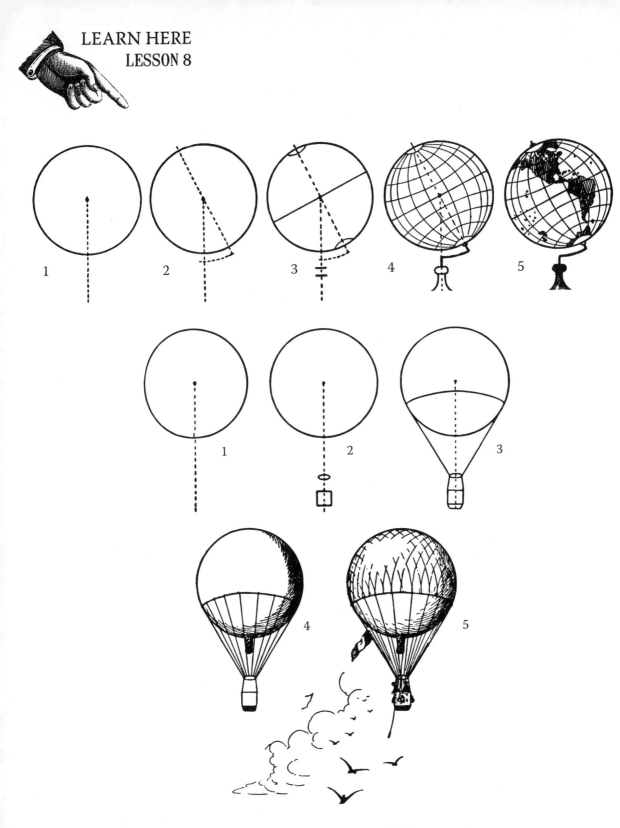

GLOBE AND BALLOON

The globe shown on this page requires some very careful work with the compass. For the middle line of the equator and the central line of the support use the ruler. In a subject such as this, where the lines are unmistakably straight, use a ruler.

PRACTICE HERE

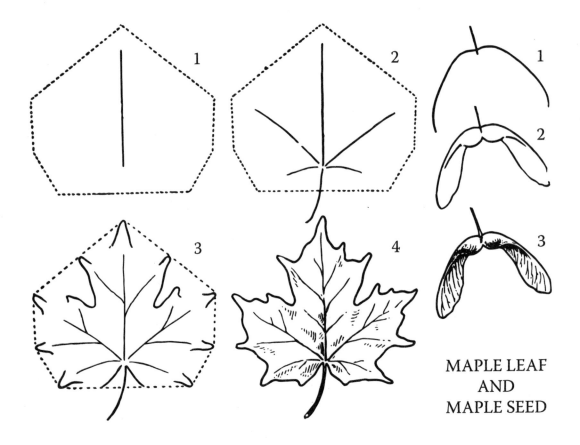

MAPLE LEAF
AND
MAPLE SEED

DRAWING LEAVES

During the summer you will find many leaves to use as patterns for drawing. The oak and the maple leaves are examples here.

If you try at first copying these leaves to mark the way the outline goes in and out, the drawing will not turn out very well. The best plan is to block out the entire space that the leaf takes up, and then draw the ribs, and after that the outline.

Be sure and draw other leaf-forms that you find in the woods or on plants. Before you begin to sketch them, give some attention to their general form and mark that first. The details are then much easier to put in their proper places.

PRACTICE HERE

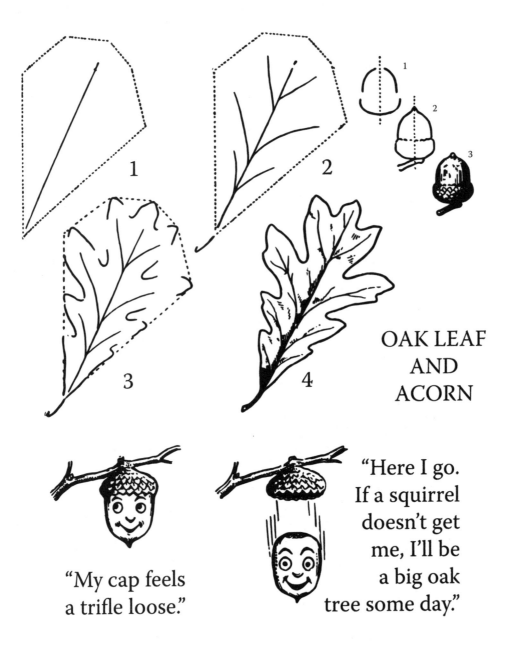

1

2

3

4

OAK LEAF
AND
ACORN

"My cap feels
a trifle loose."

"Here I go.
If a squirrel
doesn't get
me, I'll be
a big oak
tree some day."

PRACTICE HERE

BUTTERFLIES

Making drawings of butterflies is not difficult. In the images below, you will see the progressive steps to draw five. In each case it is the last figure of each series of diagrams that you are working to copy. And Figure 1, in each case, shows the first lines that you put on the paper.

It is also possible to draw butterflies in the way suggested for drawing leaves; that is, marking out at the beginning the whole space that the subject takes up.

But the five simple combinations of lines, grouped below and on the next page, are so expressive of our subjects that marking them first is the best way to start drawing the five butterflies.

Notice how one of these butterflies, in its construction lines, resembles the letter Y, while two others resemble the letter X.

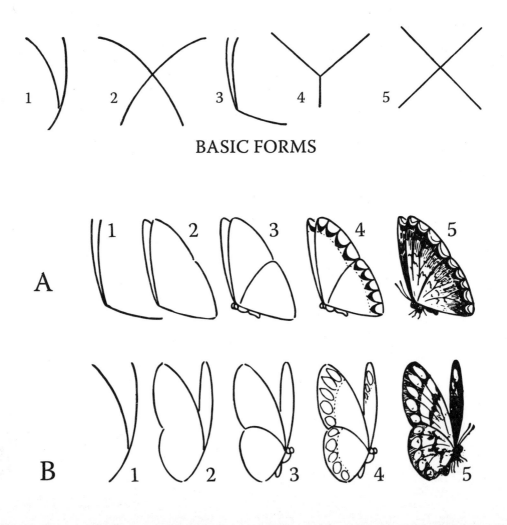

BASIC FORMS

PRACTICE HERE

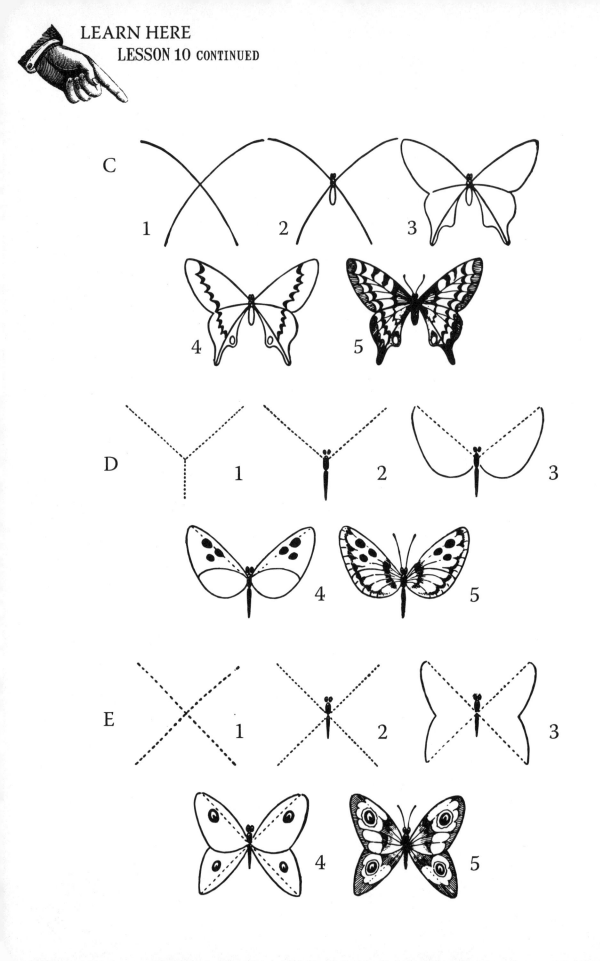

C 1 2 3 4 5

D 1 2 3 4 5

E 1 2 3 4 5

PRACTICE HERE

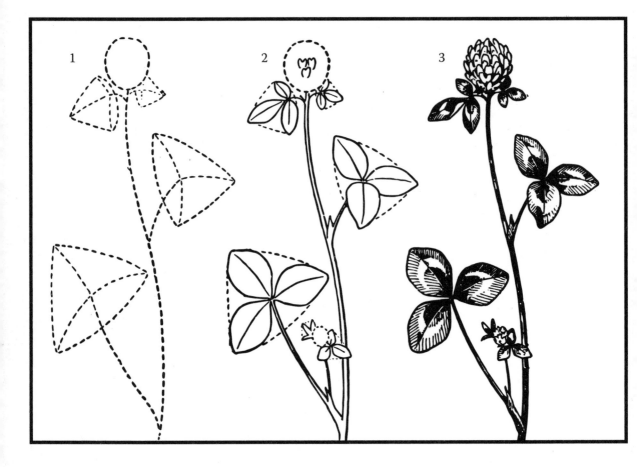

BEES AND CLOVER

The series of diagrams in this lesson show how to draw bees.

The clover blossom and leaves are blocked out first in lightly marked lines, as indicated in Figure 1. Continue with the drawing, and when you have finished it, as shown in Figure 3, try to sketch a bee resting lightly on top of the clover blossom. That is the way you often see bees when they are gathering honey in the summertime. And remember to draw one flying to the hive with its gathered honey and pollen.

PRACTICE HERE

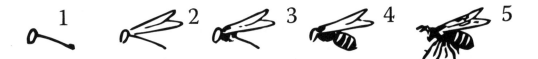

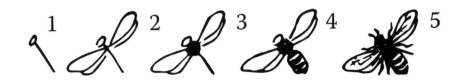

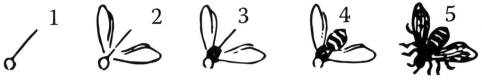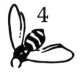

PRACTICE HERE

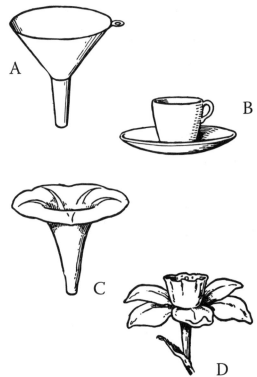

FORMS OF FLOWERS

The diagrams above show the resemblance between a morning glory and a funnel, and the likeness of a narcissus to a cup and saucer.

Now, the idea of showing these comparisons is to help you understand the forms of these flowers. As you know, it is a great help in drawing to understand thoroughly the form of the particular object that we are drawing. Take the morning glory for instance—by keeping in mind its striking resemblance to a funnel, a very simple thing to imagine, we can visualize it in simple lines and then sketch it easily.

And in the narcissus; if you do not allow the minor divisions to bother you, but see at once the resemblance to a cup and a saucer, you will know how to go about the work of drawing much easier. That is, you will plan as you start some form like a cup and its saucer, as shown in Figure 2 of the narcissus diagrams on the next page.

The pictures of bees and butterflies that you now know how to make will be good to combine with the flower sketches that you will learn to draw from the lessons on this and the following pages.

PRACTICE HERE

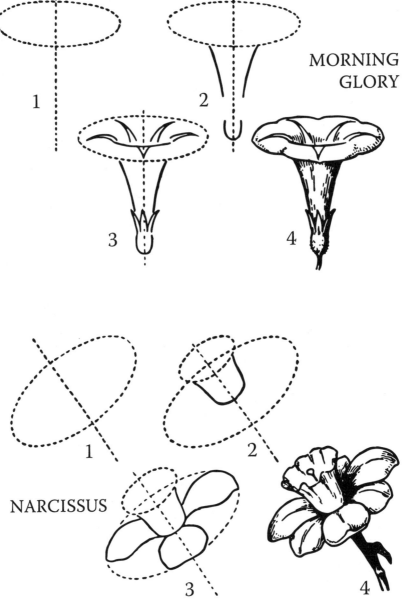

MORNING
GLORY

1

2

3

4

NARCISSUS

1

2

3

4

PRACTICE HERE

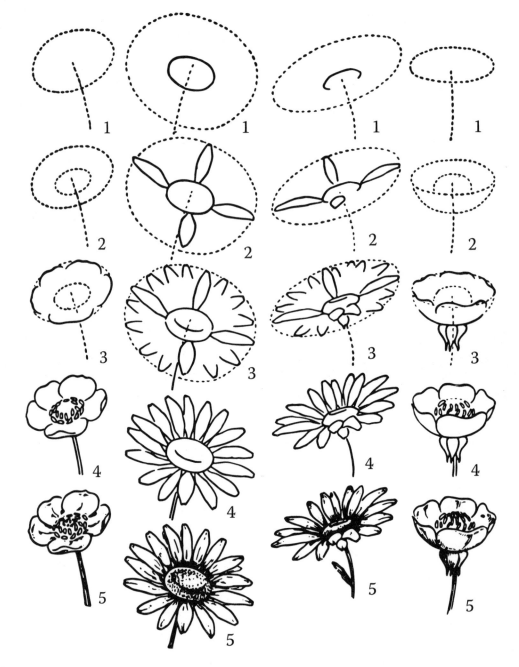

PANSIES, BUTTERCUPS AND DAISIES

The six diagrams in the next page show how to draw the outlines of a pansy, and the five varied patterned pansies below give a hint for finishing with the pencil or crayons.

The final drawing of buttercups and daisies is shown on the bottom image of each diagram on this page.

PRACTICE HERE

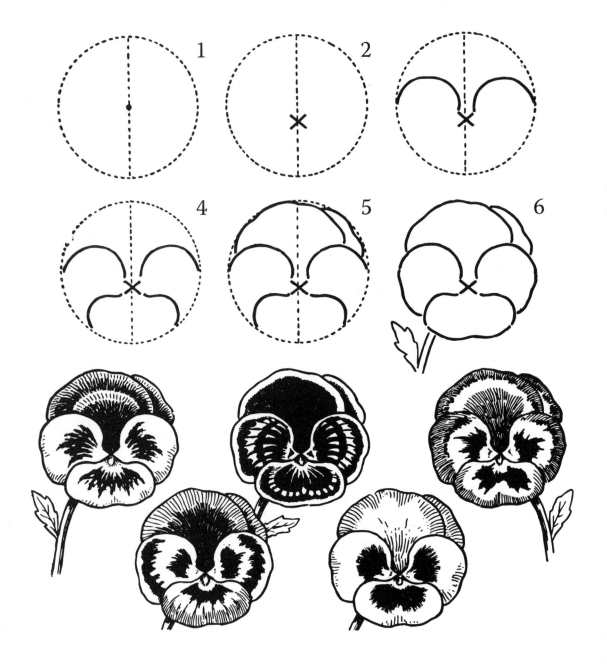

PRACTICE HERE

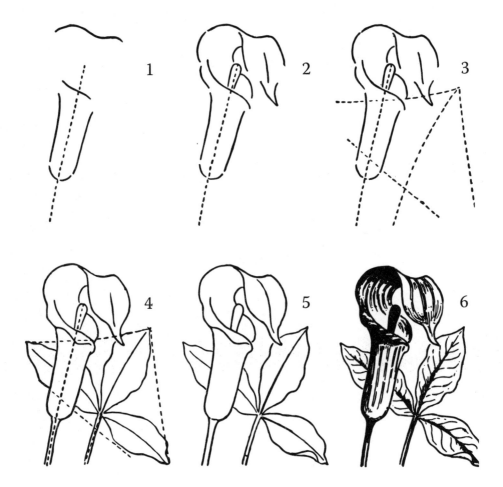

JACK-IN-THE-PULPIT AND FUCHSIAS

To draw the Jack-in-the-pulpit above, the first line to consider is the one representing the center of the flower, or its axis. Marking this lightly and keeping it in mind as you draw helps to properly place the other parts and details of the subject.

This flower is a cousin to the large calla lily, and you may find it early in spring growing in moist places in the woods.

Sketching the fuchsia is also made easier by noting the invisible central lines that go through the open flower and the bud.

PRACTICE HERE

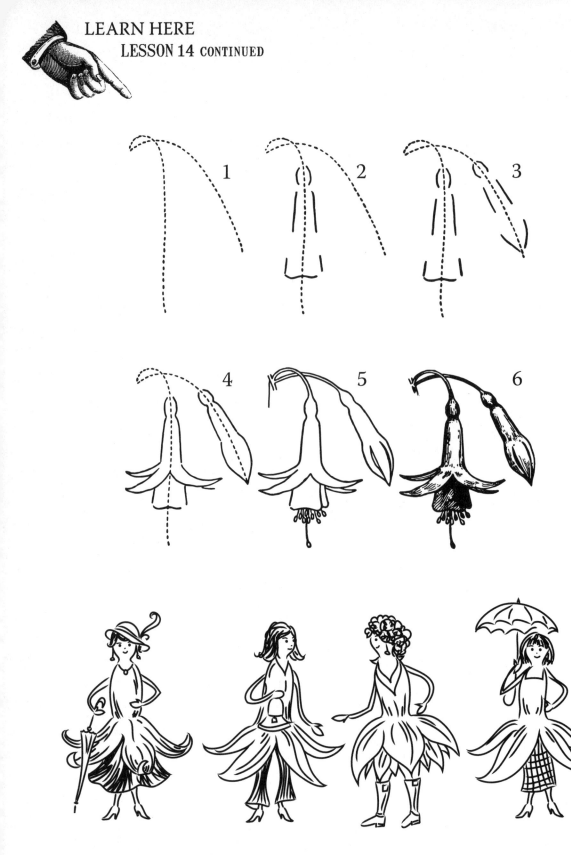

1

2

3

4

5

6

LADY FUCHSIAS

PRACTICE HERE

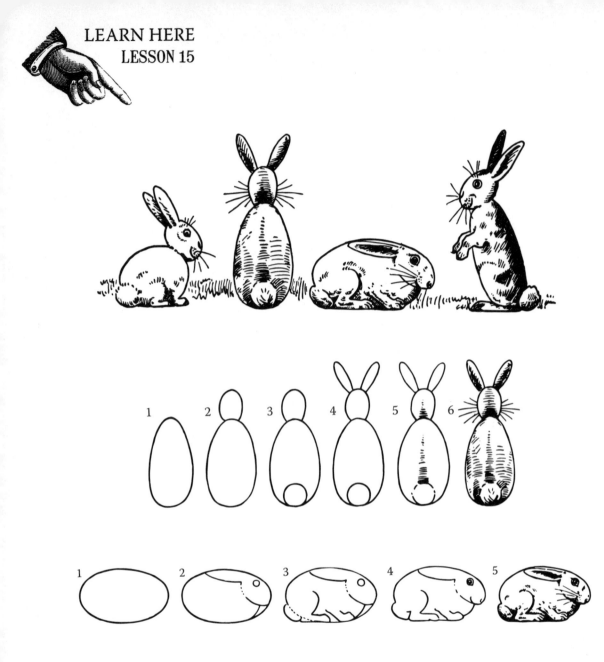

RABBITS

Here are four rabbits that will very patiently pose for you while you sketch them. It doesn't matter which of them you begin on, as the mode of procedure in each case is the same in marking an elliptical, or oval form, as the first stroke of your pencil.

In drawing one of these rabbits, keep your eye and mind most of the time on the picture as shown above, but glance from time to time at the series of diagrams to see the steps that you follow to complete it.

PRACTICE HERE

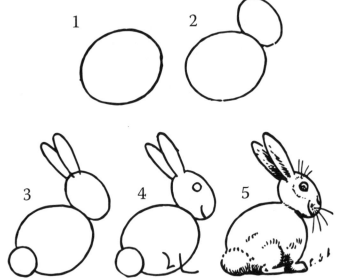

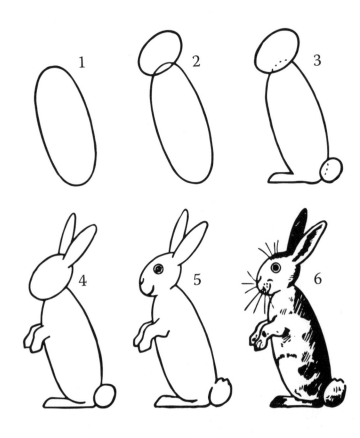

PRACTICE HERE

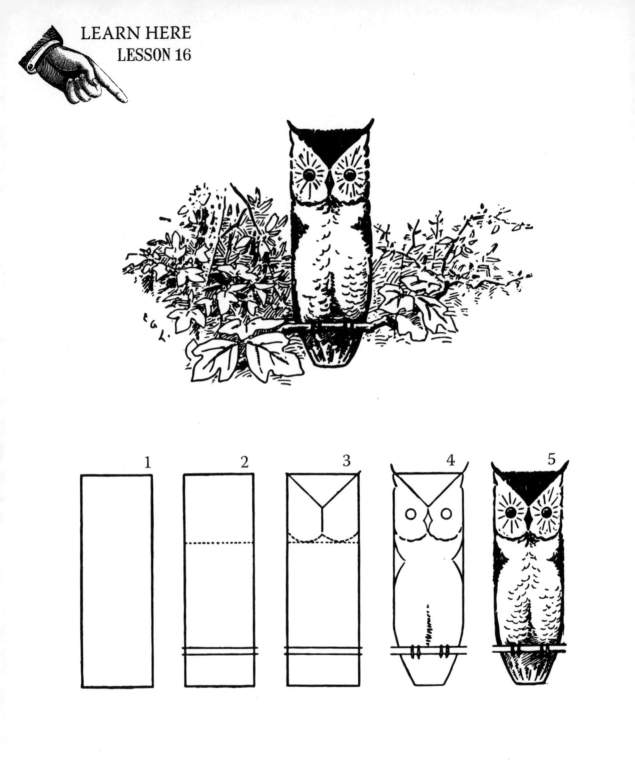

OWLS

Owls are very obliging and friendly models. When you go to the zoo try your hand at sketching them. It will not be very difficult, for your owl model will most likely keep very still and only blink its eyes.

PRACTICE HERE

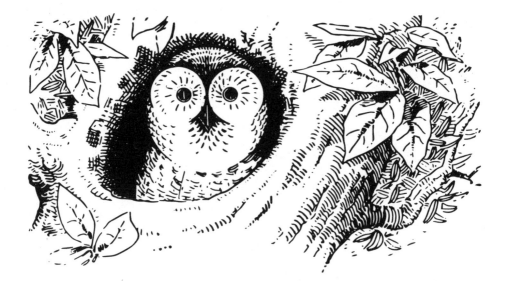

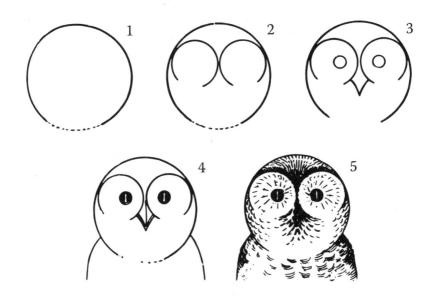

Mark the first lines faintly and get them as round as possible, entirely by free hand.

PRACTICE HERE

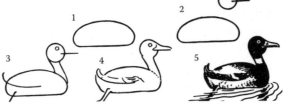

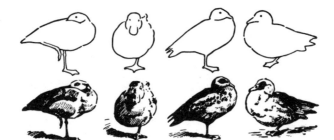

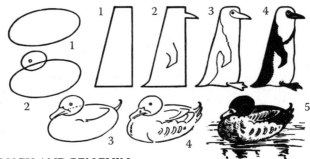

DUCK AND PENGUIN

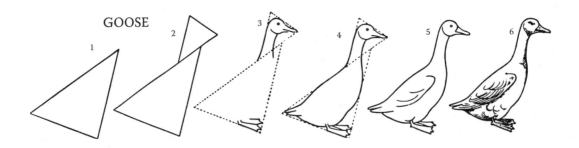

OTHER BIRDS

Other birds at the zoo that sometimes keep quiet long enough for you to sketch are the ducks, geese, and cranes. Often they rest themselves on one leg and stay that way for some time. Drawing a bird in this position is not as easy as it seems. It's important to consider him balancing on one leg, and not toppling over, when you put down the pencil strokes at the start.

PRACTICE HERE

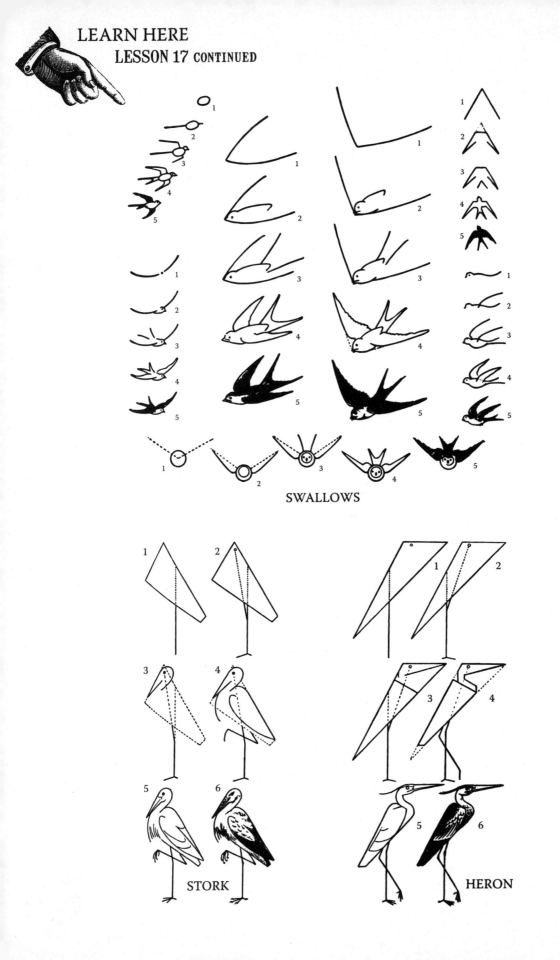

SWALLOWS

STORK

HERON

PRACTICE HERE

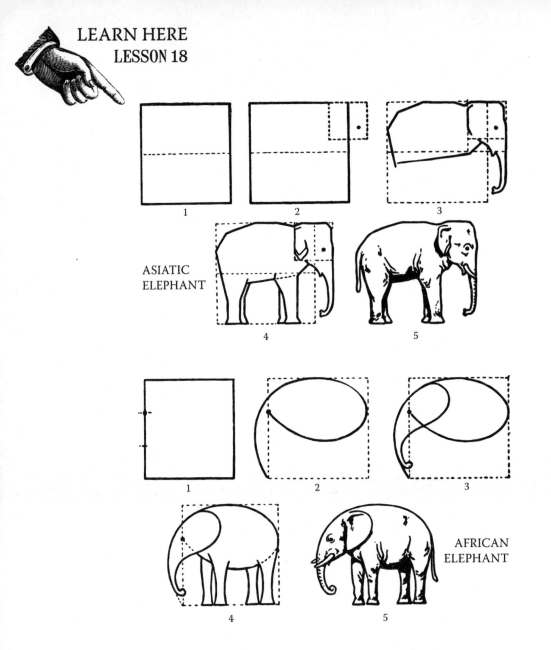

ASIATIC
ELEPHANT

AFRICAN
ELEPHANT

ELEPHANTS, DOG AND MONKEY

The kind of elephant that one commonly sees at the zoo is the Indian elephant. It has a thick-set body and small ears. Sometimes, however, you see the African elephant. You will know it at once by its huge ears. The ears look, especially when the elephant moves them, like large fans. There are other differences between these two elephants, but this difference in the size of the ear is the main one. The progressive steps in making a drawing of these two elephants are shown on this page.

To draw the running dog in the next continued lesson page, first construct two squares side by side, indicated by dotted lines, and then mark a firm curved line, as in Figure 1. When you have proceeded to drawing the body, you will have some resemblance to the complete sketch shown by Figure 5. Then move on to try drawing the funny face of the monkey by making a circle and then a smaller one intersecting it below.

PRACTICE HERE

RUNNING DOG

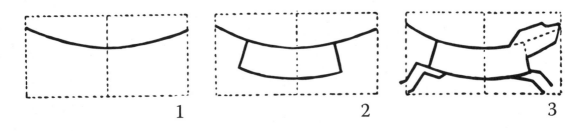

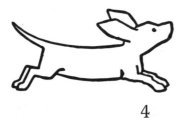

4

5

MONKEY

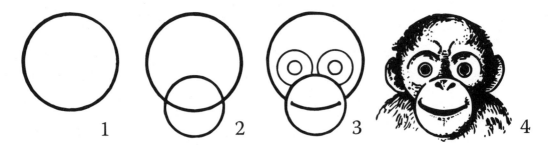

1 2 3 4

PRACTICE HERE

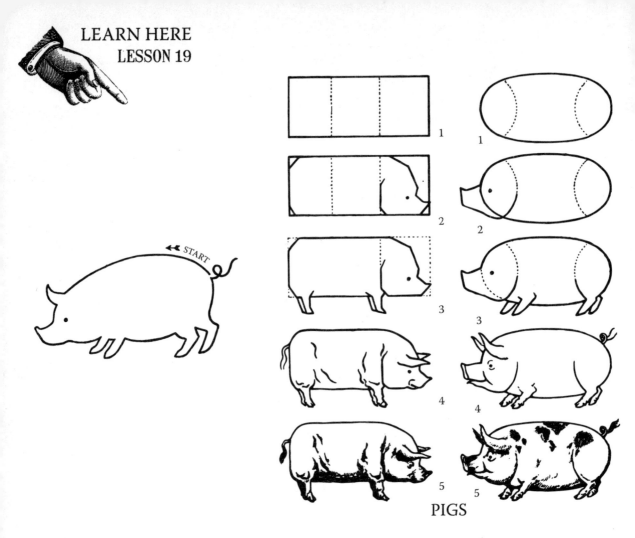

PIGS

DRAWING A PIG WITH A SINGLE LINE AND WITH THE EYES CLOSED

Here we have the drawing of a pig in a simple outline, which is a drawing for you to follow. However, make your drawing with your eyes closed, or not looking at the paper, and in one unbroken line. Now, drawing in this way, using only the inner vision, calls our attention to one great fact about drawing. It is this:

Drawing is first a matter of the mind, and
only secondly a thing of pencil and paper.

When you are trying this little exercise of drawing a pig with your eyes closed and without lifting the pencil from the paper, you are forced to hold and keep in your mind the image of a pig. You can understand then that although we need pencil, brushes, and paints in picture making, the first thing needed is an idea or an image in the mind of that which we wish to portray.

The images on the right have two types of pigs; one is of a somewhat square character in his outline, while the other is a jolly round fat one. Diagrams 2 and 3, of the pig of a square character, are good examples of the blocking-out method in drawing.

PRACTICE HERE

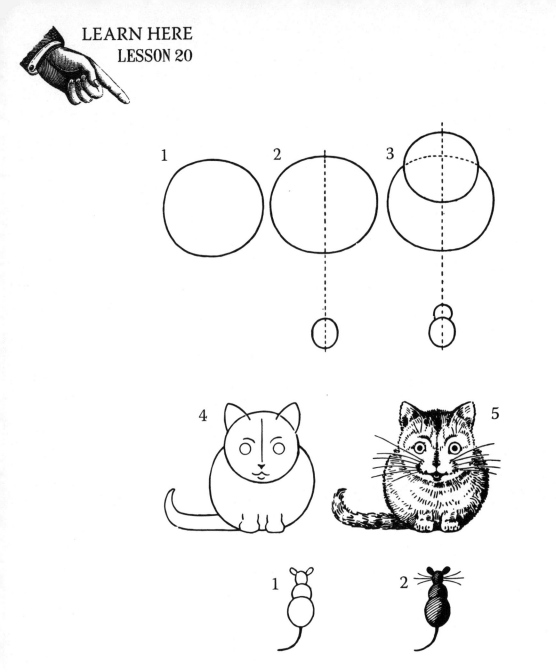

CAT AND MICE

In drawing the very surprised cat with the bold black mouse in front of it, drawing a vertical, or up-and-down line through the centers of the two forms with which the drawing is started helps to keep these animals in their correct positions.

The right way to begin to draw a mouse is to make a simple form that gives a general idea of his body, as the mere addition of a curlicue for a tail gives a fairly good portrait of a mouse. If the cat on this page were to turn around, all the mice would scamper away. That is a good way to draw them. Try it.

PRACTICE HERE

CAT

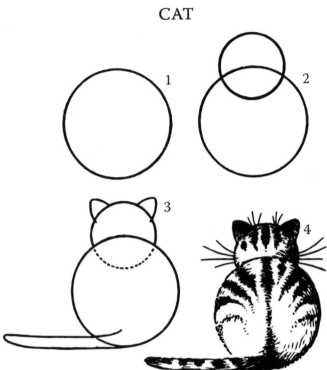

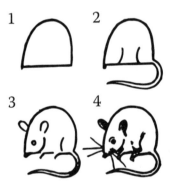

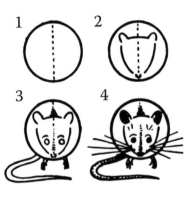

MICE

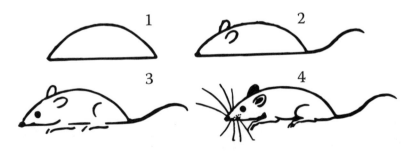

PRACTICE HERE

BIRD

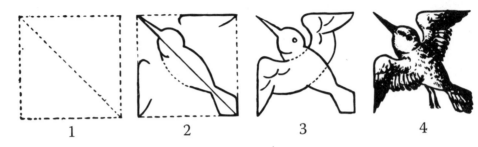

1 2 3 4

SNAIL

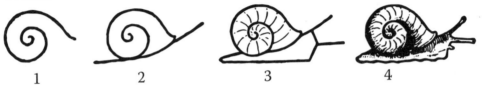

1 2 3 4

TURTLE

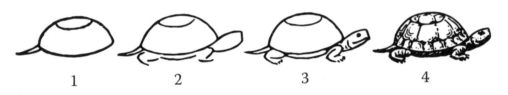

1 2 3 4

FISH

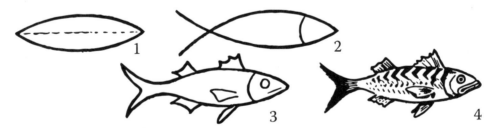

1 2 3 4

WOODS AND FIELD ANIMALS

After school's out, it's vacation time, when you will spend many happy hours exploring outdoors. But don't forget to keep drawing. Good subjects to sketch will most likely come your way. A tortoise, that during a ramble may cross your path, will make an easy subject to draw. The shell suggests an inverted cup.

The flicker, as you will notice, has two toes in front and two pointing backward. Notice how he uses his tail feathers to support himself as he taps the tree trunk.

PRACTICE HERE

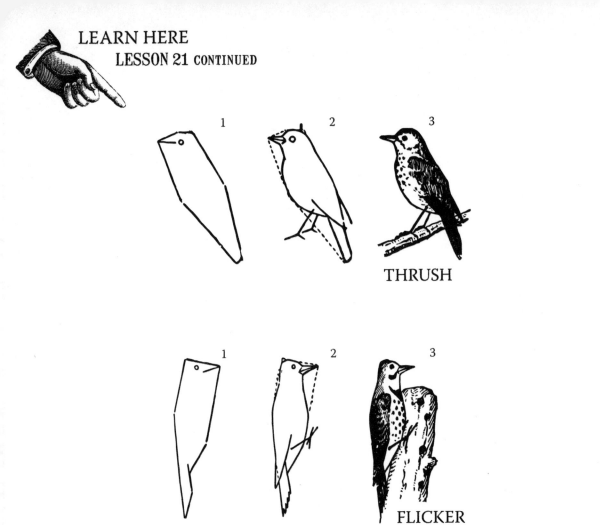

1 2 3

THRUSH

FLICKER

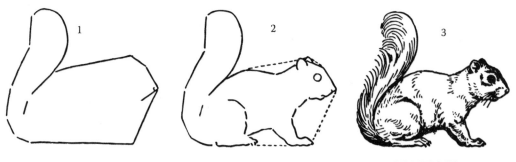

SQUIRREL

CHIPMUNK

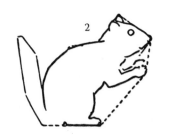
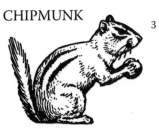

PRACTICE HERE

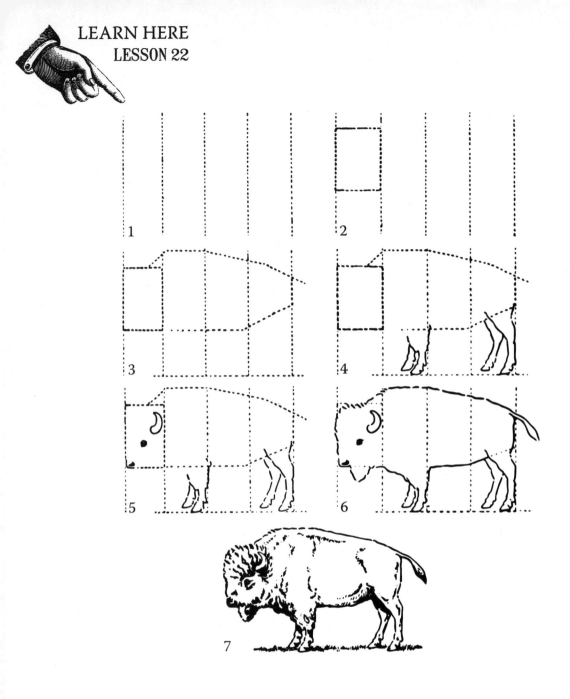

1

2

3

4

5

6

7

BUFFALO AND PRAIRIE DOGS

You can learn to draw a buffalo in a standing position by following the series of diagrams on this page. The crinkly mass of the buffalo's head is rather hard to represent in lines with a lead-pencil. The proper tool is a brush filled with color with which you can paint quickly the large mass of hair and get the outline soft and woolly, as it really is in nature. However, you will learn something by trying to do the best you can in following the lesson on the page. Afterward you may paint the picture with a brush and color.

The prairie dogs really don't have a very strongly defined shape apart from their fat little bodies. The simple outlines in the top images show what to draw first to indicate this character.

PRACTICE HERE

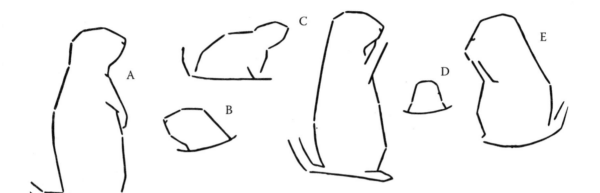

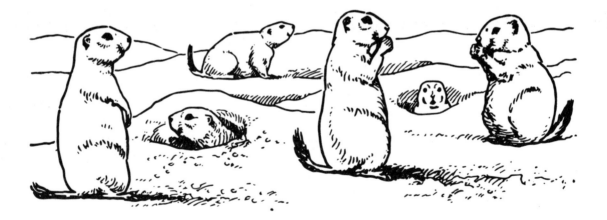

PRACTICE HERE

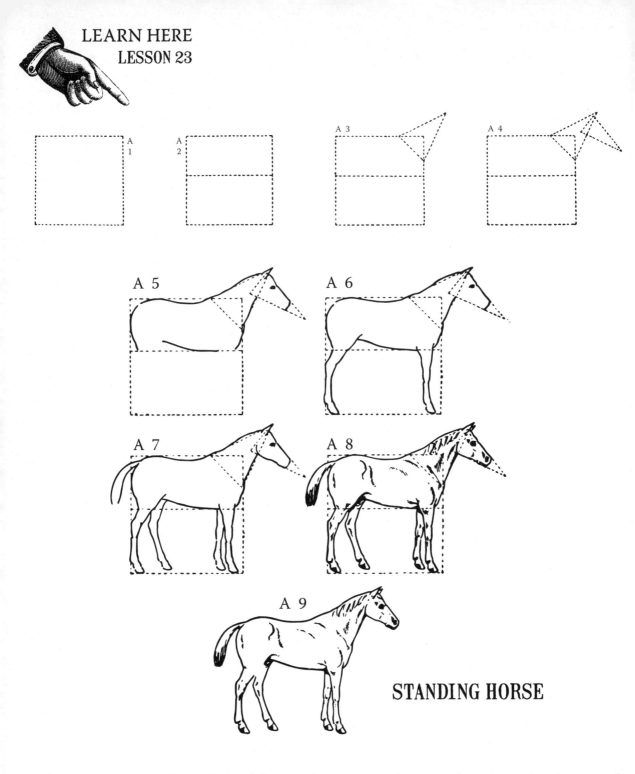

STANDING HORSE

The engravings on this and the following lesson page show you how to make pictures of horses.

In the above image, you start your sketch with a square. Draw it freehand without using a ruler or triangle. Make it as accurate as possible and then divide it into two parts with a line across it just above the middle. Now, in one corner, mark a triangle pointing obliquely upward and another triangle slanting downward. The exact procedure is shown above. All the lines that you have been marking so far should be made faintly, as they are only construction lines. The lesson is continued in the image on the next page.

PRACTICE HERE

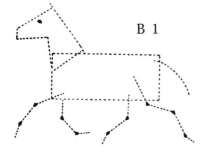

B 1

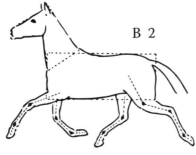

B 2

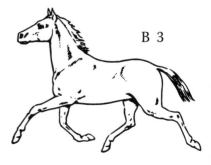

B 3

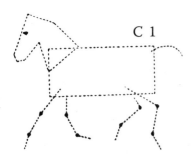

C 1

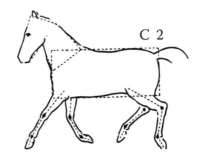

C 2

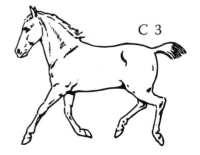

C 3

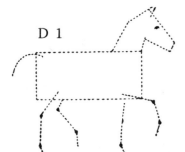

D 1

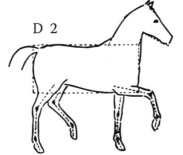

D 2

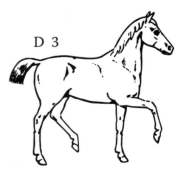

D 3

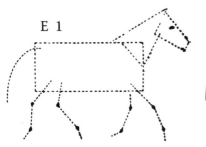

E 1

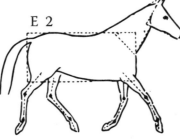

E 2

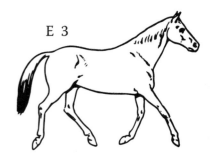

E 3

HORSES IN MOVEMENT

While drawing these horses, keep the general proportions in mind, as illustrated by the 4 diagrams in the image of the previous page's lesson.

PRACTICE HERE

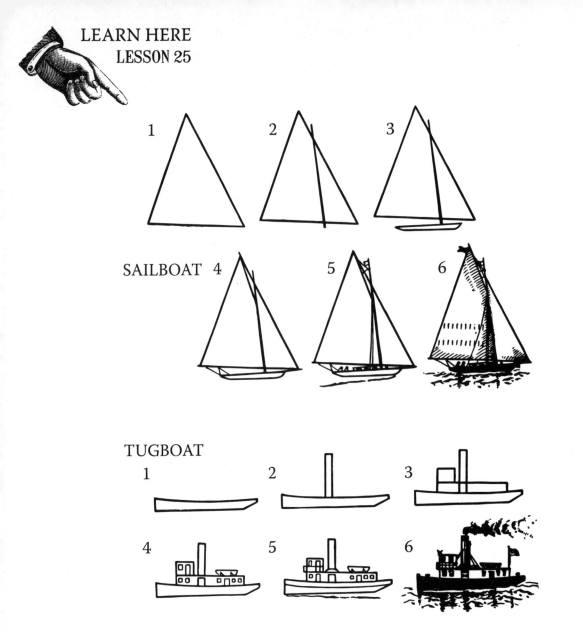

HOUSES AND BOATS

In these lesson pages are two lessons in drawing houses that have a whimsical way to go about drawing them.

In one case start by marking a V turned upside down. The drawing soon becomes a tent and then a house when a chimney is added. In the other case a house is built by progressive steps that begin with a lozenge-shaped design.

There is no need to hesitate when sketching the sailboat illustrated on this page. A triangle, easily drawn, gives the idea of a sail at once. With adding a line for the mast and an indication of the hull, we have the picture almost completed. The tugboat is made by sketching, with strict regard to the proportions, the hull and the smoke-stack. These are the two most conspicuous parts, and so should be indicated at once.

PRACTICE HERE

1

2

3

4

5

6

7

8

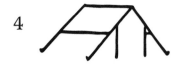 1

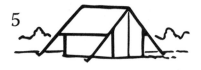 2

3

4

5

6

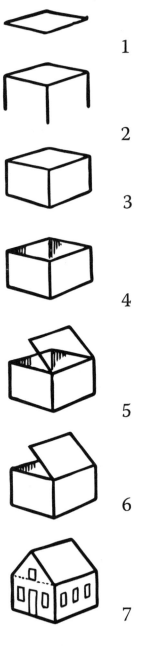 7

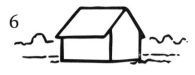

 8

PRACTICE HERE

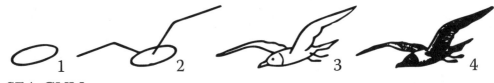

SEA GULL

FLYING FISH

CRAB

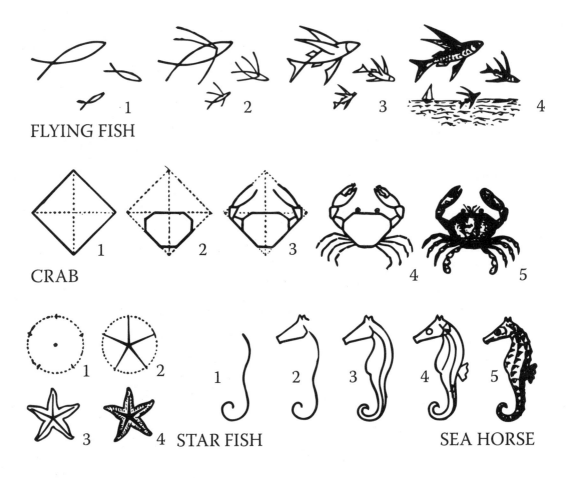

STAR FISH

SEA HORSE

FORMS OF OCEAN LIFE AND SAILBOATS

A few forms of ocean life are portrayed here. If you have not been lucky enough to have seen these creatures at the seashore or in aquariums, you are at least familiar with them through pictures. See how every line in the flying fish diagrams expresses speed in flying.

PRACTICE HERE

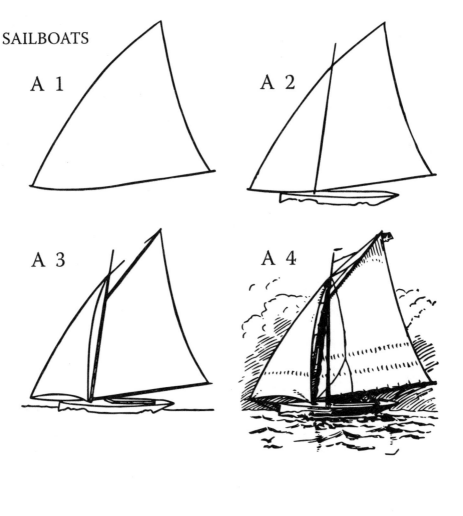

SAILBOATS

A 1

A 2

A 3

A 4

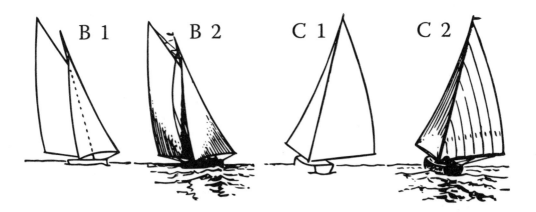

B 1 B 2 C 1 C 2

PRACTICE HERE

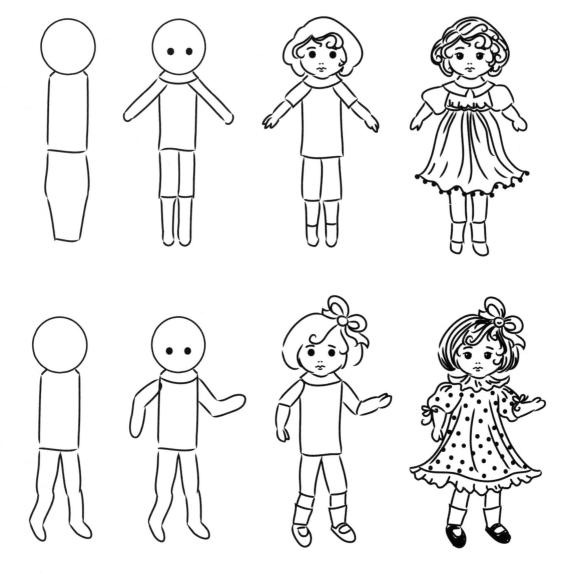

DOLLS

Here are some interesting subjects to draw. The first figure in each series—a circle for the head and a simple outline for the body and limbs—should be sketched with careful attention to the proportions. Notice that the eyes are placed in the lower half of the circle. To help you place them properly draw a line across the middle of the circle before you begin to draw the face.

After you have copied the dolls as they are shown here, see how much imagination you have by clothing them in different styles of dress.

PRACTICE HERE

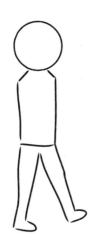

 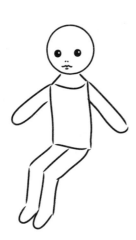 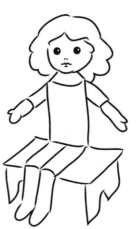

PRACTICE HERE

LEARN HERE
LESSON 28

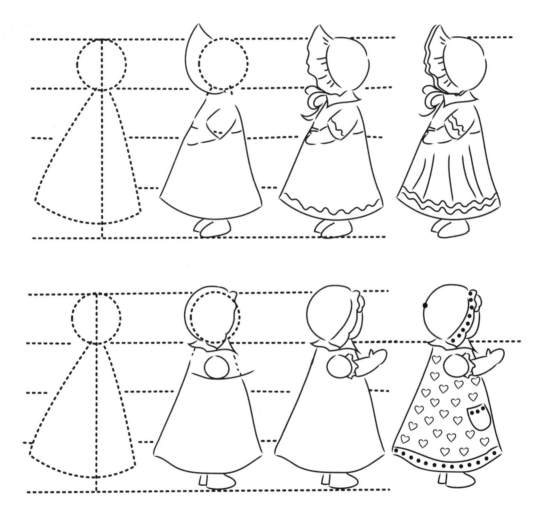

CHILDREN

When drawing the child with the sunbonnet, or the one with the cap, begin by making a circle for the head and an apron-like form underneath it. Mark your first lines lightly and make the head one-fourth the entire height of the figure. Drawing a figure just four times the height of the head—as if dividing it—is called getting a figure in the proportion of four heads. This is the right proportion in which to draw pictures of very young children such as those on these two pages.

You will notice in these images that parallel dotted lines run across the diagrams. They are not intended to be drawn this way, but are only to remind you of the right proportions in which to draw these pictures. Of course, if it will help you in your work, you may mark them when sketching. The children here are represented as standing very quietly. Farther on in the book you will be given suggestions on how to draw pictures of children in action.

PRACTICE HERE

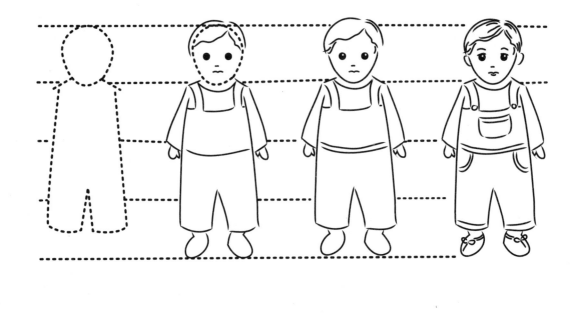

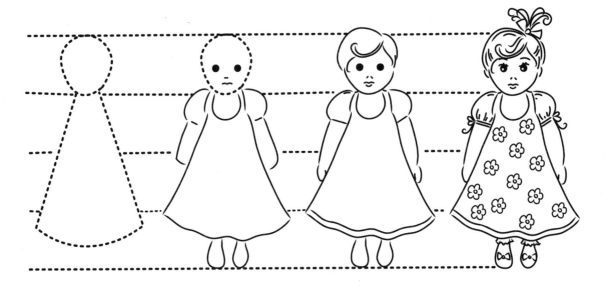

PRACTICE HERE

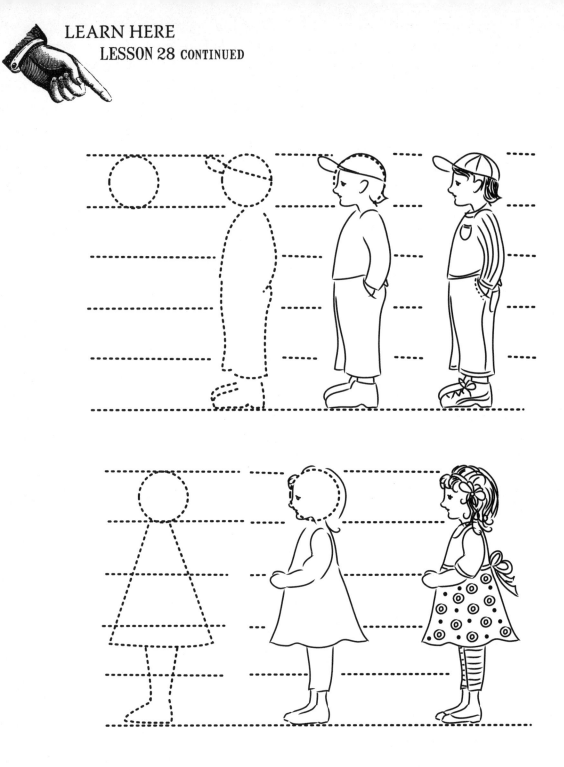

Here again parallel dotted lines crossing the diagrams show you the proper proportions in which to draw these older children. But on these lesson pages, the figures are drawn in five heads.

The babies in the preceding lesson were drawn four heads high because they represent younger children.

PRACTICE HERE

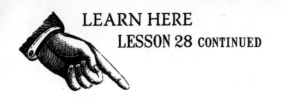

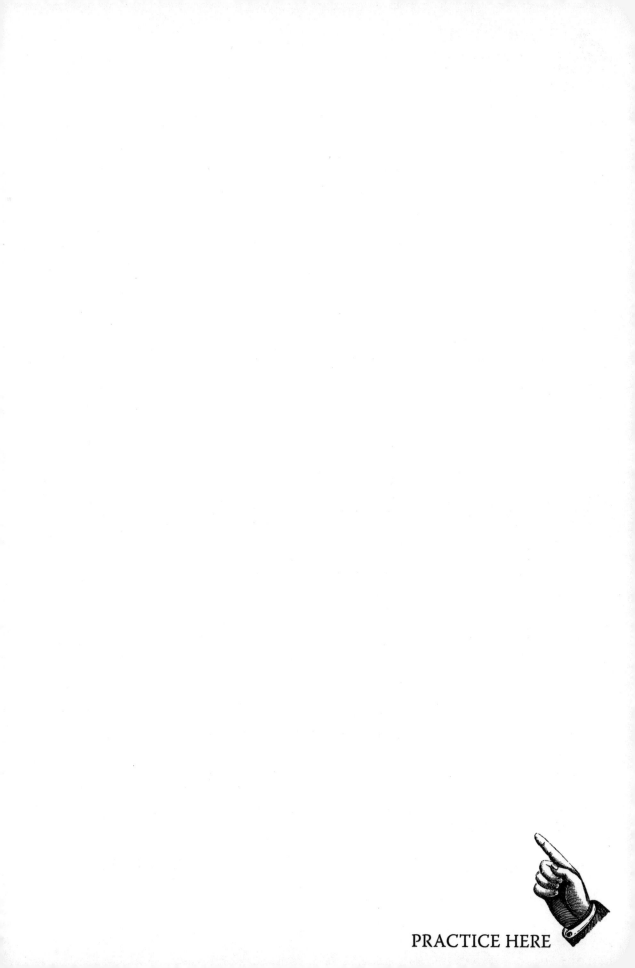

PRACTICE HERE

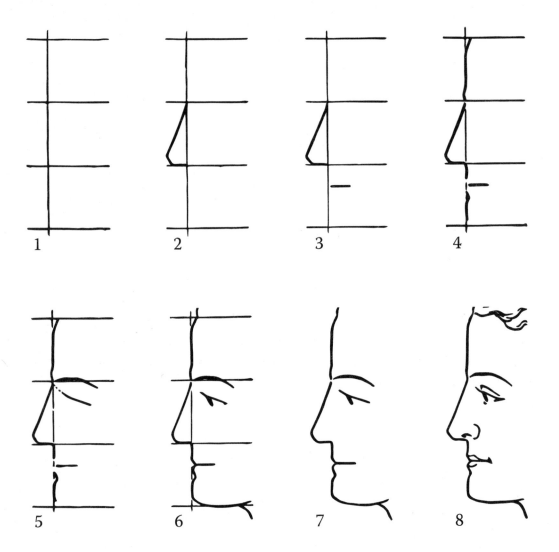

DRAWING FACES IN PROFILE

Drawing the side view of a face is shown above. In the top image, Figure 1, an up-and-down line is divided into three equal parts. As this is the foundation for the sketch, get it accurately marked. Notice that in Figure 3, the mouth is placed at about one-third below the dividing mark.

The images in this lesson are two lessons in drawing side profile faces simply.

PRACTICE HERE

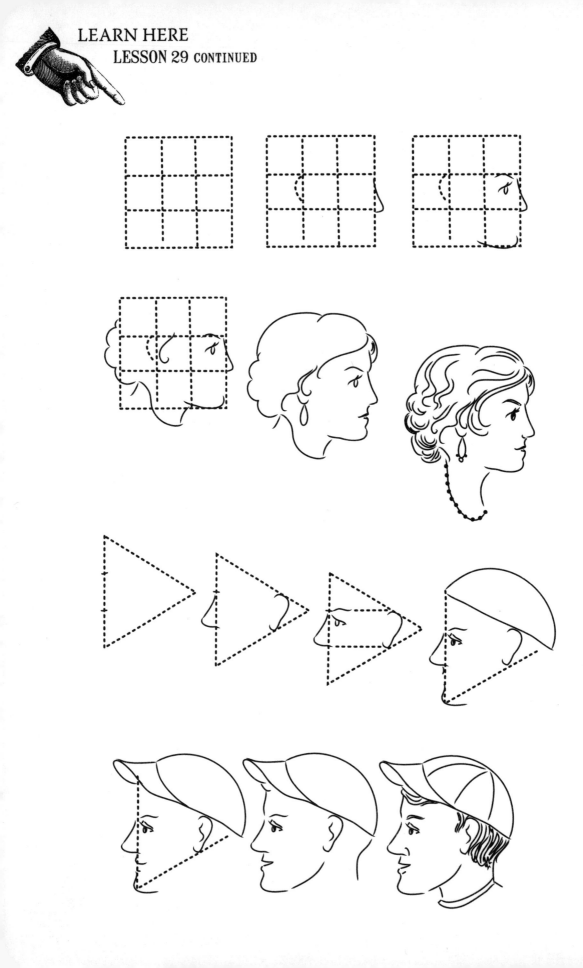

PRACTICE HERE

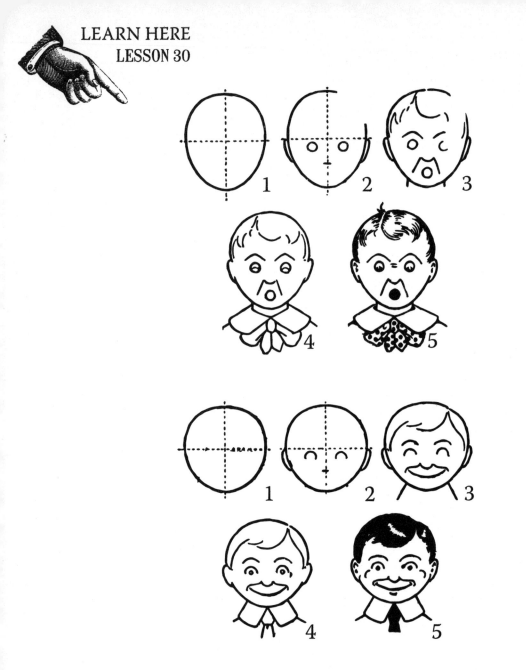

FACES

The first step in drawing one of the boys' faces is to make an oval-like form with cross-lines through its center. The line going across marks off the part of the head in which you place the lineaments, or lines that determine the drawing of the face. The up-and-down line helps in getting the lines evenly placed.

The top image in the continued lesson page is easy to draw as the steps to making it are shown by the seven diagrams. The image of four faces below it with different expressions may be drawn in the same step-by-step process as the face with the plain expression. The lower diagrams, A, B, C and D, give the essential lines for the expressions depicted above them. Compare the lines that make up the expression of the first face, the smiling one, with the lines of expression of the last one, the serious one. One set of lines is curved and pleasing, while the other set is angular and severe.

PRACTICE HERE

EXPRESSIONS

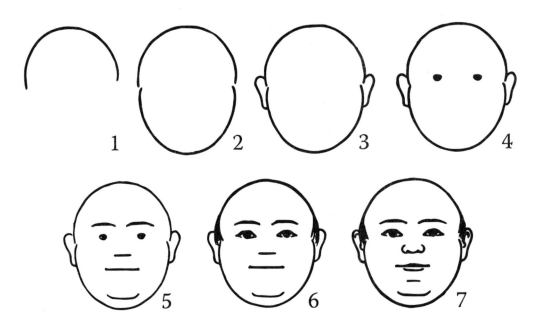

1 2 3 4

5 6 7

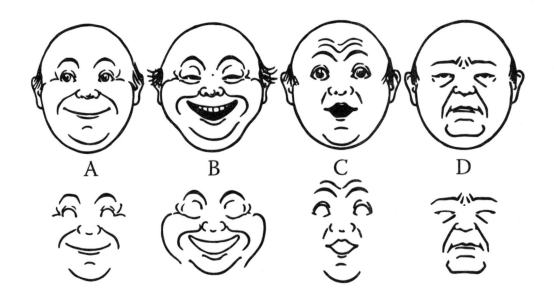

A B C D

PRACTICE HERE

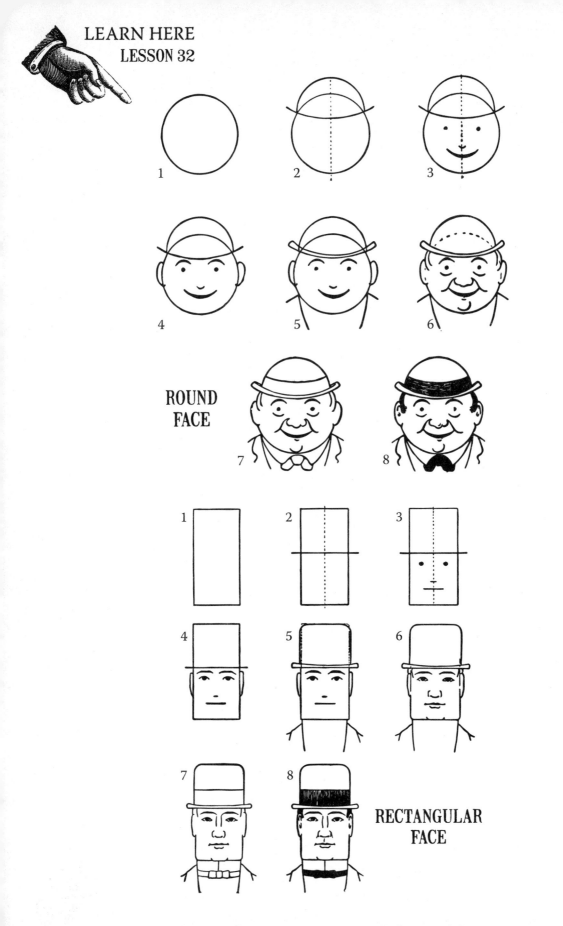

ROUND FACE

RECTANGULAR FACE

If you're feeling silly, here are some more whimsical faces to try.

PRACTICE HERE

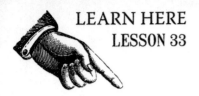

CHARACTER SKETCHES

In these character sketches notice how the peculiarities of feature repeat themselves in the faces

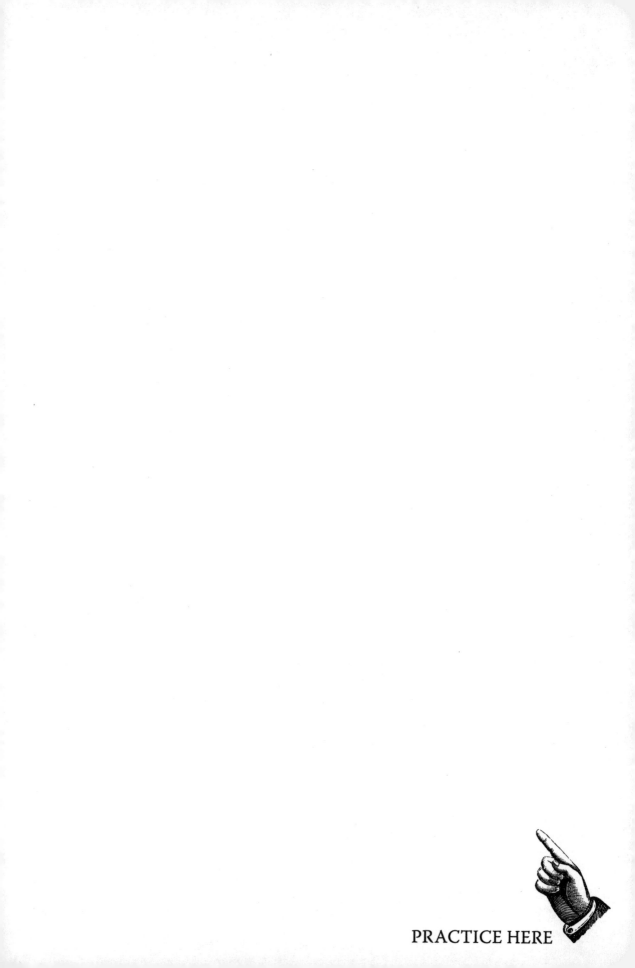

PRACTICE HERE

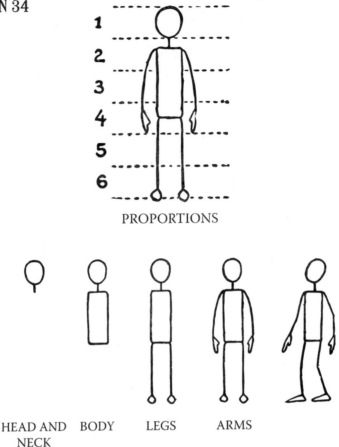

1
2
3
4
5
6

PROPORTIONS

HEAD AND BODY LEGS ARMS
NECK

SINGLE-LINE ACTION FIGURES

An oval-like outline for the head, a roughly drawn oblong for the body, and four lines for the limbs are the few elements needed to draw these figures. The limb lines can end in markings to resemble hands and feet.

A few lessons back, children were drawn in the proportion of four heads, and some older children in five heads. Now these action figures are planned to be six heads high. The diagram at the top of this page shows this. Study this diagram carefully, and for practice, make many sketches of the simple standing figure. When you have done this and become familiar with the relative proportions of the figure, study and draw the images showing them in action in the following lessons.

Note how balance is maintained by the bulk of the figure being distributed equally on each side of a vertical line. But in falling, you will see, a large part of the figure is on one side of this vertical line. In a slow walk the figure seems nearly balanced, but in running it is drawn as if falling forward.

When you are uncertain as to which line to mark first in any of these drawings, study the particular image and find the line that expresses the movement best. Keep that line in mind as you draw.

PRACTICE HERE

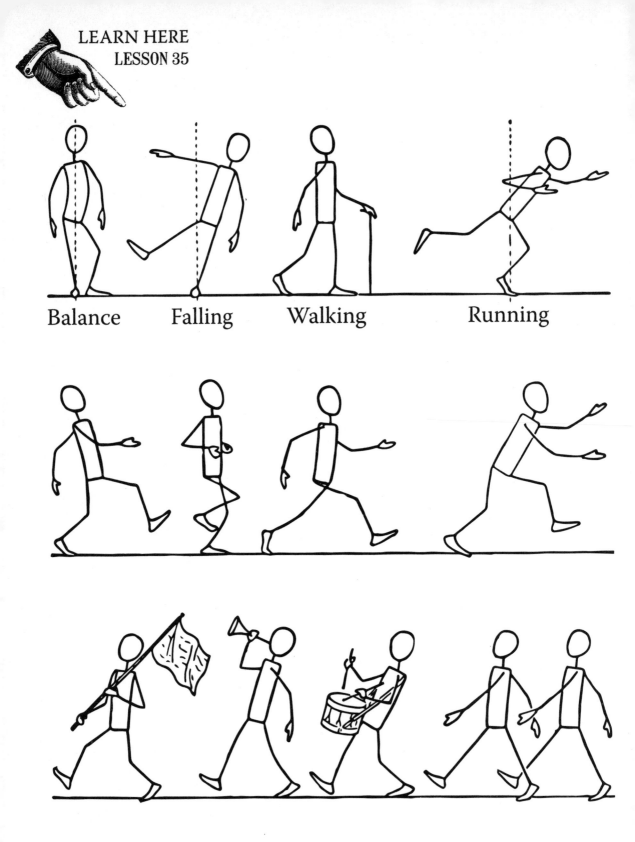

Balance Falling Walking Running

DEGREES OF ACTION

The slant of the body and the way the lines of the limbs are marked determine the degree of any action. But the placement of the head are just as important. This means thought before marking the direction of the short line representing the neck.

PRACTICE HERE

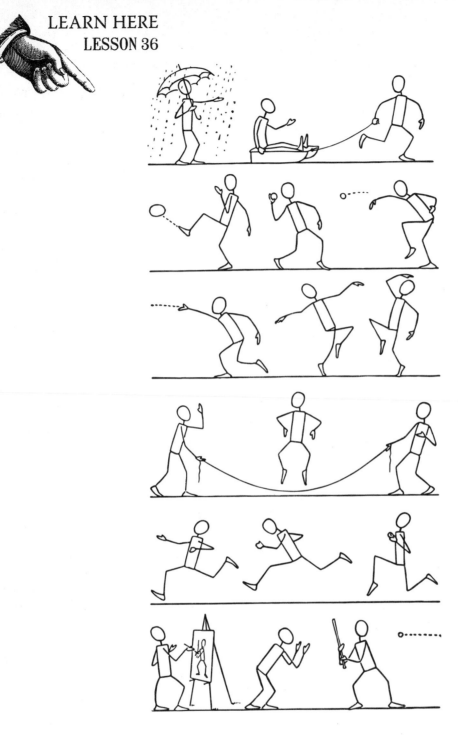

FIGURES IN ACTION

You can make many more sketches than those shown here. Use this method for making drawings of the many activities of your play hours. Watch your companions at work and at play and see the attitudes they take.

When you draw these figures in action try to imagine yourself going through the particular action you are trying to sketch. It helps wonderfully.

Study movement by the observation of the action figures in the busy everyday world.

PRACTICE HERE

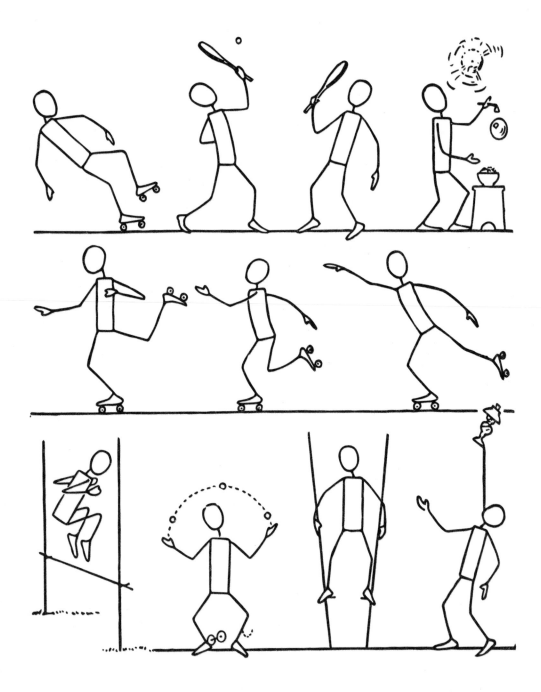

FIGURES IN CLOTHING

Make complete pictures of these little figures by clothing them. Then you will see how much imagination you have.

PRACTICE HERE

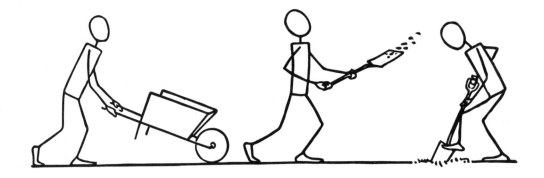

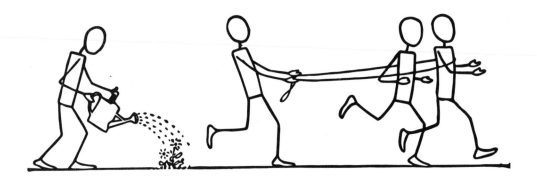

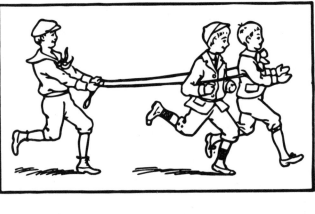

PRACTICE HERE

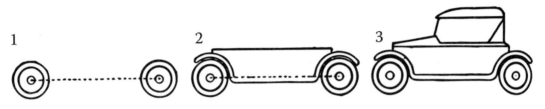

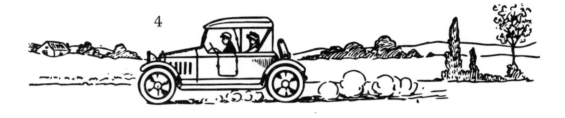

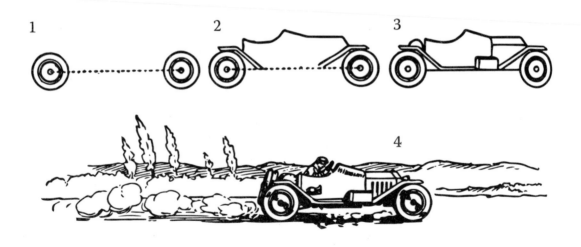

AUTOMOBILES, AIRPLANES AND SEAPLANES

Two automobiles are shown above the way they look when passing by on the road. The wheels in this case are circles; in sketching them you can use the compass if needed. If the automobiles were going in some other direction instead of passing directly before you, the wheels would appear to be different to you. They would take on the form of an ellipse and would need to be drawn free-hand.

When you draw the airplanes, notice the slant of the lines that define the wings. Certain groups of these lines go to an invisible point in the distance. The artist speaks of them as lines going off in perspective toward a vanishing point.

PRACTICE HERE

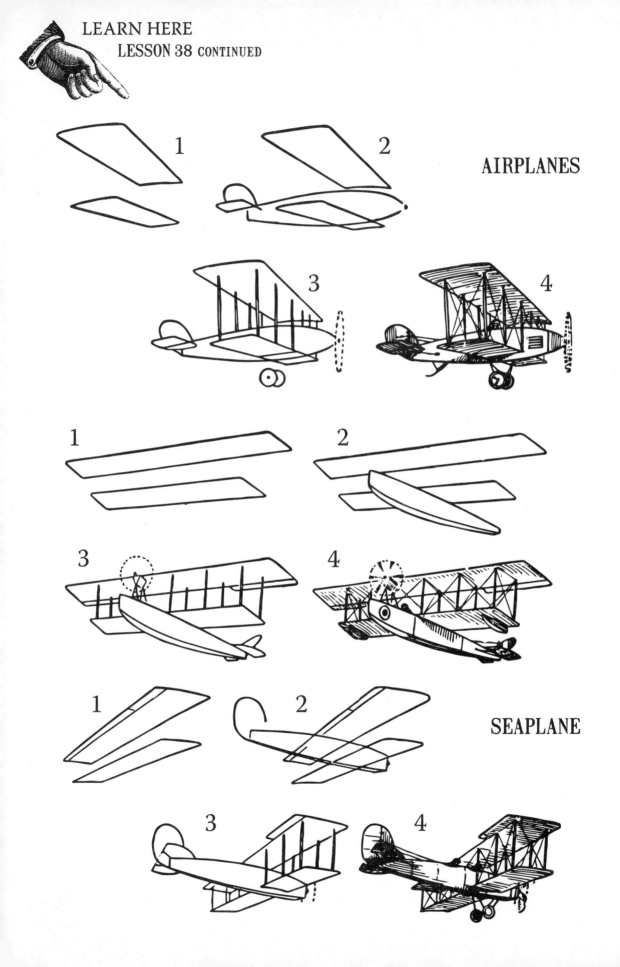

AIRPLANES

SEAPLANE

PRACTICE HERE

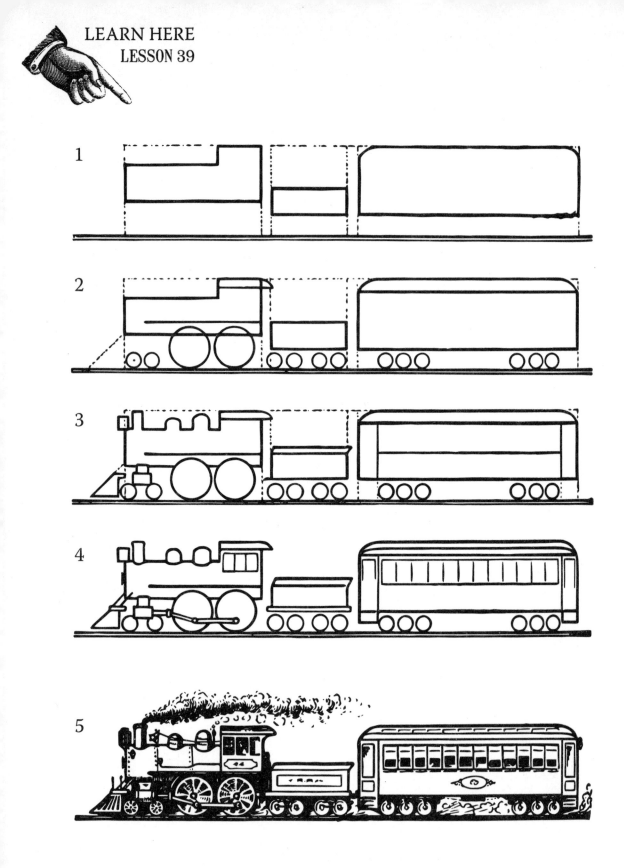

1

2

3

4

5

LOCOMOTIVE AND CAR

In drawing the images in this lesson, you can use a ruler for the construction lines, or a triangle with the ruler to get the right angles correct.

PRACTICE HERE

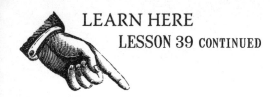
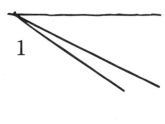

1

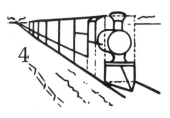

2

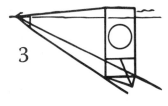

3

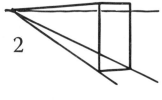

4

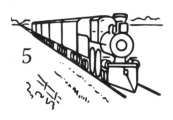

5

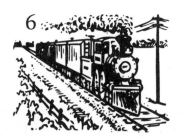

6

1

2

3

AN EASY
LESSON IN
PERSPECTIVE

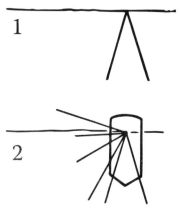

1

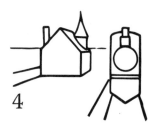

2

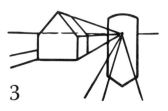

3

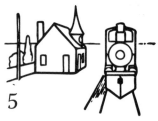

4

5

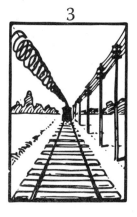

6

PRACTICE HERE

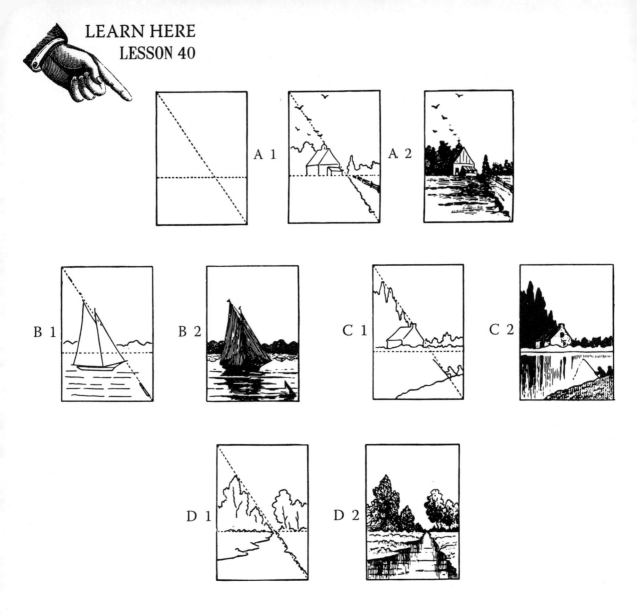

DRAWING LANDSCAPES

Here we have a few landscapes to study and draw. It is as important for you to study them as it is for you to make copies of them. There are a total of ten images, see Figures A, B, C and D, falling into three groups. Note that each group is founded on the simple arrangement of lines shown by the diagram on this page. These lines serve three purposes. 1) If sketched first they aid in drawing the various parts of the picture in their proper places. 2) They link the parts of the picture together so that it has a sense of completeness. 3) They give the picture some interesting lines to attract and hold the attention of the eye.

The other groups of pictures, Figures E, F, G, H, I and J, have more complicated schemes of arrangement. But by marking a rectangle and then the leading lines as shown the drawing is easy work.

Color your landscapes, if you wish, with the crayons or watercolor paints.

PRACTICE HERE

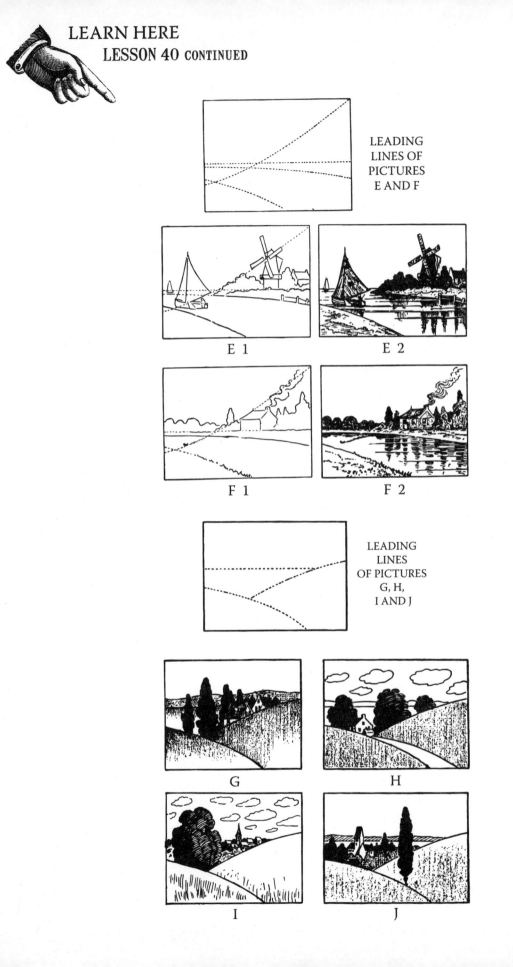

LEADING
LINES OF
PICTURES
E AND F

E 1

E 2

F 1

F 2

LEADING
LINES
OF PICTURES
G, H,
I AND J

G

H

I

J

PRACTICE HERE

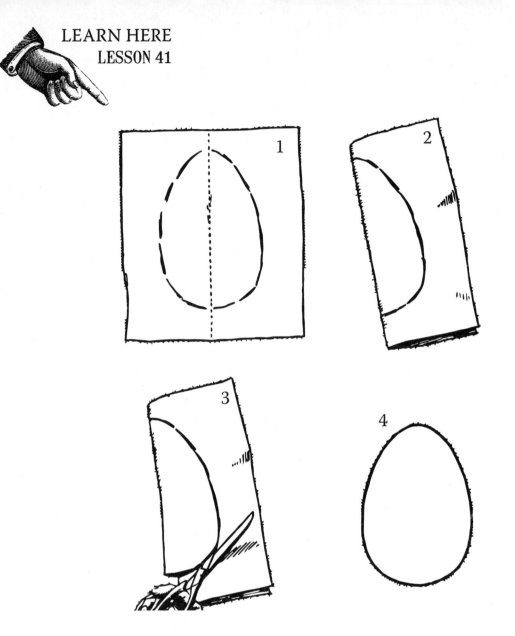

AN AID IN DRAWING OVALS

An oval has an outline like an egg, with one end rounder and fuller than the other. No doubt, when you have tried to draw an oval you have found it difficult to get it evenly shaped with the outline firmly marked. One simple trick to draw an oval is to cut a pattern out first and then use this pattern to trace the outline.

The way to make an oval pattern for tracing is shown above, the steps are:

1. Roughly sketch an oval on a sheet of paper.
2. Fold the paper so that the fold goes through the long middle line of the oval.
3. Cut out the oval, through the folded paper, with a pair of scissors. Cut with a firm, steady hand, so as to get it in an even curve.
4. Open the paper, and you will have an even and symmetrical oval pattern.

PRACTICE HERE

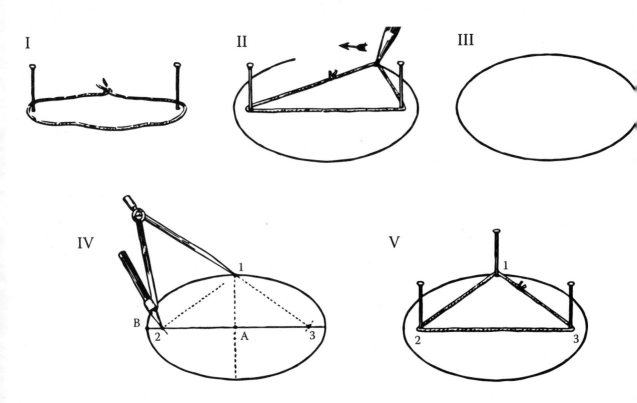

TO DRAW AN ELLIPSE

There is an important difference between an ellipse and an oval. In an oval the fullness of the two ends is not the same, while in an ellipse the two ends are exactly the same.

When you draw a wheel in any other position but one directly before you, give it the form of an ellipse. Turn back to the image in Lesson 37 and see the comparison between a wheel in a side view and an ellipse.

Figures I and II of the image above show you how to go about drawing an ellipse. To determine the places for the pins and the size of the loop:

IV. Take the pencil compass and fix the legs so that they measure the distance from A to B. This is one-half of the long central line of the ellipse. Now place the point at 1, and cross the long line and 2 and 3 with your pencil.

V. Stick pins into the paper at points 1, 2, and 3, and tie a string around them. Take out pin 1, replace it with the point of the pencil, and then proceed with the problem as in Figure II.

PRACTICE HERE

BEGINNING TO DRAW

To draw from a flat image is not difficult but few beginners find it easy to make a sketch from solid or real objects. The usual way in elementary art instruction is to provide the pupil with an outline of something to be copied. For most of us, imitating by drawing from a copy—that is, another's rendering of something in the visible world—is easier than making one's own interpretation of the subject. The accomplished master or genius, of course, would find it irksome if asked to copy another's work.

But should drawing from the actual objects be so hard? Wouldn't it be just as simple as working from the flat image if the student could believe that the visual rays from all the points of the object, or the view, were brought forward to an imagined plane? If this plane with the object or view were outlined in this way, the student would simply need to think of it as a huge flat copy to be faithfully imitated.

Many mechanical tools for drawing have been contrived. Of these the camera lucida and the camera obscura, both requiring the use of either a lens or a prism, are more optical instruments than tools for simplifying the work of delineation.

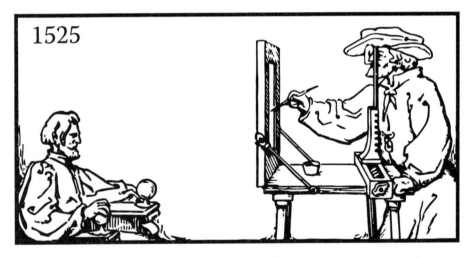

1525

APPARATUS FOR DRAWING INVENTED BY DŰRER

Imagine a windowpane on which a view of the street or buildings outdoors is traced. This pane of glass would correspond to the hypothetical plane above. Albrecht Dürer mentioned a machine in his book on the art of measuring. It consisted of a transparent surface placed between the subject and a single eye-piece through which the artist could look and trace on the plane the outlines of the subject. This gave the artist a one-eyed view, so to speak, of the model. Other inventions of a similar nature have been made, some using a transparent gauze that could be easily marked with a pencil. It would appear by the bowl on the table of the apparatus in Dürer's picture, that he used a liquid and painted the image on the transparent surface. This invention is considered more a novelty than a practical tool.

PRACTICE HERE

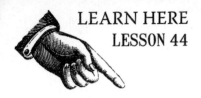

AN UNCERTAIN WAY OF MEASURING

The idea of considering the subject or view as nothing but an ideal flat picture on an imaginary plane, to be transcribed on paper, seems at odds with the ideas of the realist who shudders at viewing the perceived world in this way.

But for beginners it is helpful to consider everything we see as an aggregation of areas, outlined and variously colored and shaded. It is important to render on paper, or canvas—as the case may be—the effects of roundness, bulk, and dimensions. You must begin to learn by making the first strokes on the paper in lines or forms more or less geometric in aspect, rather than attempting to sketch at first the elusive bends of curves or the subtlety of contours; also, in the beginning it would be better to work with simple straight lines.

This may not represent the subject exactly. Perhaps, but it is more likely to approximate reality than a drawing that is the result of trying to copy the exact blending of the tints and shadows on the first try.

When dealing with curves, keep it simple. Rare is the draftsman who can successfully get the curves of the human figure without more or less blocking out with straight lines.

PRACTICE HERE

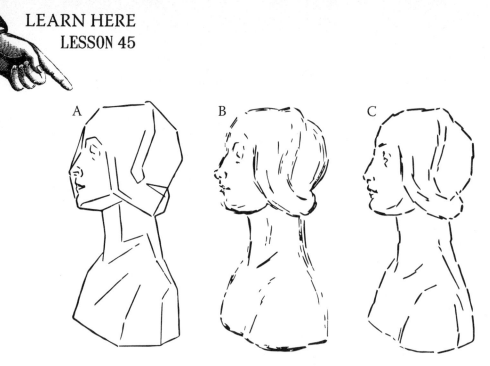

CHARACTER OF OUTLINE

A Simple straight lines, assuring a strong drawing.
B Fumbling and broken lines, the contour is unclear.
C Weak and indefinite strokes. Drawing likely to be formless.

DRAWING THE CAST OF A HEAD

"But how do I begin?" is the first thought that enters a student's mind, when with paper, drawing-board, and charcoal, he presents himself before a subject ready to work.

There are many methods of drawing but there is but one way of starting, which is to start "big" and to start quickly.

To begin at one point, say the eye, and gradually build the drawing around that in a detailed, small way, is not the right method. Neither is to begin at the upper left-hand corner and gradually work downward to the right, as is often advised so as not to smudge the work.

The best way to answer the question of how to begin is to give specific examples showing and explaining the progressive steps as we go along.

Say that you are going to draw the cast of a head (see diagram above). Place it directly before you in a light that will keep the shadows as much as possible in large masses, and the side in light not too broken up with shadows. This trying to get a pleasing distribution of light and shade on the cast is part of learning how to draw. Doing this will help you understand the importance of getting a good light-and-shade effect. Of course, in trying to get a good distribution of light and shade, the half-tints must be considered. They are needed in order to bring out the forms. Now place yourself back from the cast a little more than three times its greatest dimension—breadth of height, width, whichever is greater. Never get nearer.

Start quickly and mark something on your paper. This does not mean to mark without thought. Of course, study the cast first for a few minutes by mentally analyzing it and seeing what gives it its particular form, that is to say, what differentiates it from other casts.

PRACTICE HERE

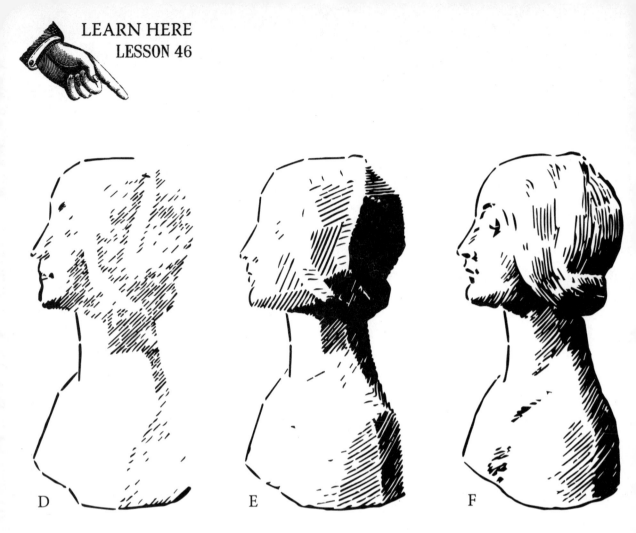

D E F

D An even tone put on first, nearly a half-tint. Try to work this way, and keep the shading in simple unbroken tones.

E Reduce shading to an aggregation of flat areas of tints from darkest to the lightest. A good way to work if not overdone or carried too far.

F Try to get the exact effect of roundness with the first strokes of the pencil or charcoal. This way of starting will result in unclear forms, looking less like the subject than a drawing made in simple flat tints. Not a good way to start.

METHODS OF BEGINNING THE SHADING

To continue: Get an idea of the contour of the subject as soon as possible for a basis on which to begin to criticize. The ability to be a good critic of your own drawing, whether you work in a classroom or your own studio, is very important to the study of art.

Think "big" and your drawing will have that quality of bigness necessary for a complete work of art. The habit of working on one little part of a drawing and finishing that first, and then going on to another part will not teach you to express unity, agreement, and harmony—all qualities which are essential in any composition to which the term "bigness" can be applied.

PRACTICE HERE

HINTS ON DRAWING THE CAST OF A HEAD

Sketch in the outline of the general mass of the head, in lightly drawn lines, simple and straight, rather than curved ones.

It's not possible to make this whole contour in one single step, so it is important to know which of the lines forming it should be the first to be put down on the paper.

Now, the first line to draw is the longest, the most prominent one. In all cases it should be the one that you think fits the above requirements. If you have made a mistake, you will find it out during the process of the drawing. This self-discovery will be more educational than if someone had shown it to you.

The next line is of secondary importance, following on to the third and the fourth, and so on until the general contour takes shape. Keep in mind that the lines are only suggested, drawing them lightly so that they can be erased and changed without difficulty.

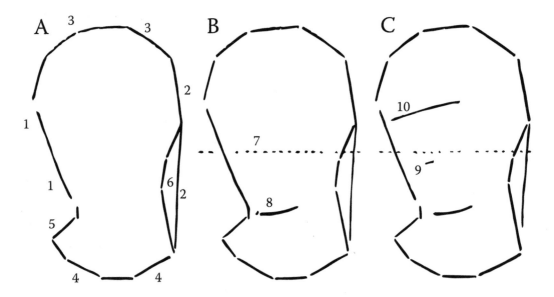

A Mark with lines at top and bottom the intended size of the drawing, then important lines 1 and 2 to indicate the width of the drawing. Complete with lines 3 to 6.

B Divide the height equally by line 7. Note that the bottom of the chin, line 8, is exactly in the middle of the lower section.

C The base of the nose, line 9, is a little bit below the center. The brows, marked by line 10, are easy to place as they are at the same distance from the base of the nose as they are from the bottom of the chin.

PRACTICE HERE

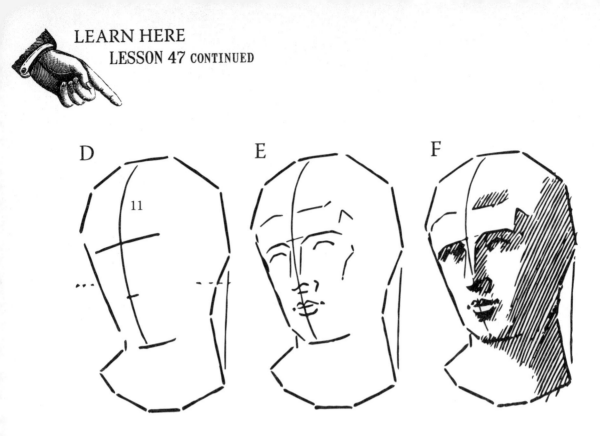

D Getting the features "even" depends on the proper delineation of line 11.
E Now indicate the features in simple lines, keeping in mind their position with reference to line 11.
F With quickly drawn oblique lines, mass in the shadow side in an even tint. Now there is enough on
 your paper to show whether or not your constructive work warrants going on with the drawing.

When lines are vertical or horizontal it is easy enough to judge them, but when they slant it is an entirely different matter. The way to estimate the degree of the slant in any oblique line is to compare it with a line that can be readily judged, i.e., a vertical or horizontal one. It is plain to see that a plumb-line is the simplest example of a vertical line, so it seems only natural to use in testing degrees of inclination of oblique lines.

The problem with frequently using a mechanical aid as the plumb-line is that its use is habit forming. Use a plumb-line if you wish, but remember that eventually your unaided eyes must be able to judge slanting lines.

Sometimes it helps a little to hold up the pencil horizontally at arm's length—if you can hold it actually horizontal—and note the angle that the sloping lines make with the straight edge of the pencil. Or hold the pencil out and move it between your eye and the model as if tracing the direction of the line in the air. This is called getting the feeling of the line. It will help you understand the cast to make such invisible drawings in the air. It may look odd to a spectator to see you make mysterious gestures in space, but so what? The practice will give you a better notion of the subject and makes rendering the drawing easier.

PRACTICE HERE

DRAWING FROM LIFE

The usual pose of the life class model is a standing one in an easy attitude, the arms hanging by the sides or maybe one bent with the hand resting on the hip. The principles of drawing can best be grasped by the study of these simple standing poses. Many students are impatient with such poses, and are constantly wanting to have the model placed in some "fancy" pose or one that can be utilized in a composition or work that they have in mind. But practicing and studying the simple standing poses is important to emphasize the importance of two things in drawing—first, movement, and second, getting the figure standing with the feet well placed on the floor.

Before starting a sketch from life, mark a line at the top and one at the bottom of the paper to show the limits within which you intend to keep the figure. Always do this. A small matter, it may seem, but it is best to train yourself to keep the size of the figure as you have determined on at the start.

Then when in pictorial compositions the demands of perspective require that a figure be of a certain size, doing it will be much easier. If between the marks limiting the size of the figure any correction is needed, make it within the space marked. For instance, if you find that the legs are too short, do not lengthen your drawing, but make the body shorter.

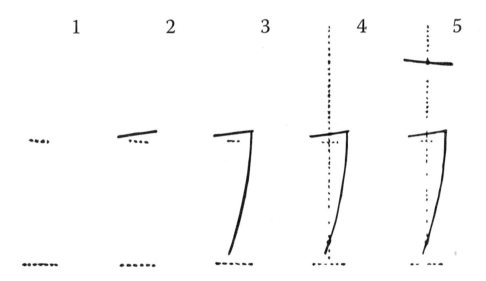

1 Mark top and bottom of the figure and a line half-way between.
2 See where the widest part of the hips comes and indicate its slope.
3 Draw line of action of the supporting leg.
4 Draw a perpendicular line cutting through where the ankle will come.
5 Mark the position and slope of the shoulders. The center of this line (head of sternum) will cut the perpendicular line.

PRACTICE HERE

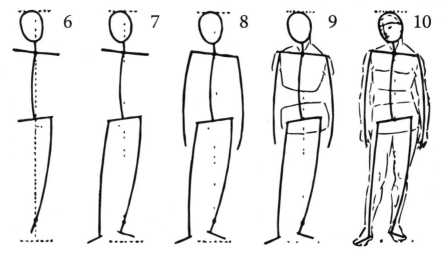

6 Sketch the head, note especially its poise and that the line for the neck continues into the line for movement or action of the body.

7 Indicate the action of the other leg. The sketch so far ought to give a suggestion of the general movement of the pose.

8 Draw the lines for the arms.

9 In beginning to outline the body note that the chest is sort of a bony box, and the region of the hips also a sort of box. The movement of the figure has a significant effect on the flexible part of the torso between the more or less fixed forms of chest and hips.

10 As you continue, keep in mind proportions and movement and see that the figure is coming together nicely.

Getting the proportions and making measurements are complex matters. Some advocate first marking off the classical or ideal height and constructing a figure to fit that. This may do when drawing a figure for some practical work. Others begin by first finding out the number of heads (7 or $7^1/_2$, as the case may be) that the model before them exhibits. They do this by arm-length measuring. It is done in this way: A pencil is held in the hand so that the thumb is free to move along its edge, the arm extended and the pencil held between the eye and the model. Now the two visual rays from the extremities of a length in question are measured on the pencil by seeing where they cut points on it—one point at the end of the pencil and the other along its edge which is fixed by placing the thumb there. This length is compared to some other similarly ascertained length. Thus taking the size of the head, relatively, on the pencil and finding out how many times, arithmetically, it goes into the whole height of the figure.

In working this way, remember that it is absolutely necessary that the arm be extended the same length every time, and the pencil held exactly vertical. Again you must not move but hold yourself in the same position so that the eye is each time at the same level and at the same distance from the model. If it were possible to keep the head fixed like an automaton, the arms moving mechanically and the pencil in the same picture plane, or no change in its distance from the eye, this would be the ideal way of working.

PRACTICE HERE

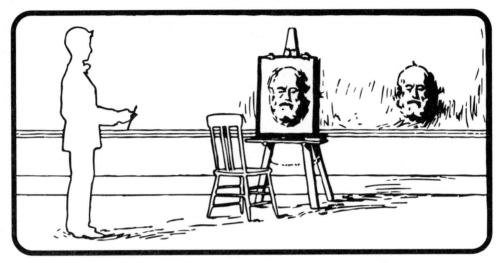

STEP BACK A PACE OR TWO FROM YOUR WORK;
THEN MISTAKES WILL BE QUICKLY NOTED.

DRAWING FROM LIFE CONTINUED

But isn't it rather mechanical?

The student may wish to try this pencil measuring and will discover very soon that after all the eye will be the best judge. How often after a lot of careful "surveying" the drawing doesn't look right anyway! Learn to depend on your own eyes.

The best way of seeing what is wrong with your drawing is to step back from it a pace or two from time to time, letting critical glances go from the subject to the drawing and from the drawing to the subject. You will then see enough faults—so many, probably, that you will not know where to begin making the corrections.

Another good way in cast drawing if it can be arranged, is to place the drawing alongside the subject and view the two from a distance or from the place where you are working.

To continue with the suggestions for drawing from life: After marking the lines at the top and bottom for the height of the figure, make another line exactly in the middle of this space. Then on the model see where the half-way point comes. This is often at the widest part of the hips. Indicate here with a line the axis of this widest part. Slant it the way you think it goes.

Before going on with the next stage of the drawing (i.e., indicating the direction of the limbs and the movement in general of the whole figure) consider for a few minutes the question of equilibrium.

PRACTICE HERE

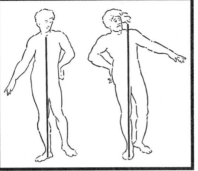

OUTLINES OF TWO SKETCHES BY
LEONARDO DA VINCI.
COPIED BY RUBENS

The human figure standing at rest is posed on a center, while movement is effected by throwing the figure off center, i.e. , having the mass of the body unequally distributed on each side of the central perpendicular or line of gravity.

FIGURE DRAWING

The center of equilibrium of a figure at rest, without leaning against or holding on to anything, is a perpendicular line cutting through the middle of the neck, through the ankle of the supporting leg, and through the floor. At the neck, viewed from the front, this line begins at the top of the sternum or breast-bone, and at the ankle—of the supporting leg—cuts through the ankle bones.

When the figure leans against anything, is in action, or is falling, the line from the head of the sternum to the ankle is not perpendicular. A little practice in drawing a few single-line action figures will make this clear.

Since you now understand that a figure in an ordinary standing pose with the weight on one leg has these two points—in the neck and ankle—exactly at the ends of a vertical line, you should begin to observe that the swing, movement, or action (three terms used rather indiscriminately by artist) takes place between these two points. The poise of the head also has an important part in this movement. The way it is held must be noted and drawn as part of the action.

Continue with the drawing, now by sketching in the line of action of the supporting leg. It should not be drawn exactly following the direction of the bones, nor will marking it the exact center of the mass always show it correctly.

No, you must draw it as you feel it to be. And this knowledge will only be grasped by thinking of the line as a part of the movement of the whole figure.

In the same way, when drawing the line for the other leg, or any line for that matter, it must always be as you feel it should be. It is too subjective for any one person to insist on your seeing it his way. You must see, understand, and grasp the idea for yourself. If you have not succeeded here and have made a mistake, the result—poor drawing in the finished work—will show it.

Remember this when drawing the figure: The chest and pelvic regions are two box-like forms nearly fixed and unchanging due to their bony structures. All movement that takes place in the torso is due to the flexible mass that connects them. When an arm moves, of course the muscles of the shoulder alter or modify this box outline.

Also, the folds of muscles of the thigh and those running to it vary the outline a little in certain movements.

When drawing from life it is a good plan to put yourself in the same pose as the model; that is to say, imitate, as well as you can, the action of the limbs and the poise of the head. This mimicry will give you a better understanding of the pose and help you better imagine how to picture it.

Note how, when the hips slant one way, the shoulders incline the other way to counterbalance it, and the head, again to preserve the balance, tilts away from the shoulder. This applies to most of poses, although some models deviate from this.

PRACTICE HERE

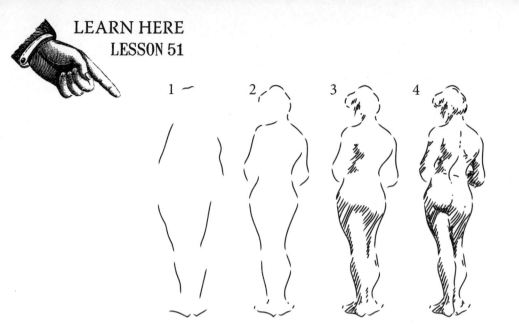

1, 2 After marking the figure's height, copy the silhouette in as few lines as you can.

3 Next put in the principal dark masses, defining their pattern as precisely as possible while working quickly.

4 Now note the general movement, the poise of the head, how it sits on the neck, and the neck to the body. Get the feeling, or show that you understand the movement—the line running from the head through the neck, body, and through the weight-bearing or supporting leg. Make certain that the figure is standing and then begin to define the shadows more accurately. If satisfied with your work so far, continue with the drawing.

THUMB-NAIL SKETCHING

ANOTHER WAY OF STARTING A LIFE CLASS DRAWING

Mark, as before, top and bottom lines to show the intended size of the drawing. Look at the subject and imagine the figure as an area with nothing more than a geometric outline. Try to copy this as you would a simple plane form, using only direct straight lines. Do not pay attention to the minute curves of the form now. Then as quickly as you can, put in the mass of shadow. Follow the pattern of the shadow areas as exactly as possible. Work quickly, because there are more important parts of the drawing than the exact shapes of shadow masses to be done first; namely, the pose, action of the figure, and the direction of the limbs, especially of the supporting leg. After this has been done, more attention can be given to the patterns of the shadow masses.

This way of drawing by imitating the differently sized and shaped areas of dark shades, middle tints, and high lights, if carried too far, is like copying the pattern of a rug. It is an excellent way of working if you can keep in mind that it is "life" that you are drawing. If carried to extremes the artist is nothing but a copyist, looking on the subject as merely a collection of variously formed and tinted patterns, and forgetting the significance of movement, proportions, and form.

However, in some unusual poses of the model, this way is useful if combined with the first method advised in which the figure is built on a simple framework expressive of action, movement, and general proportions.

PRACTICE HERE

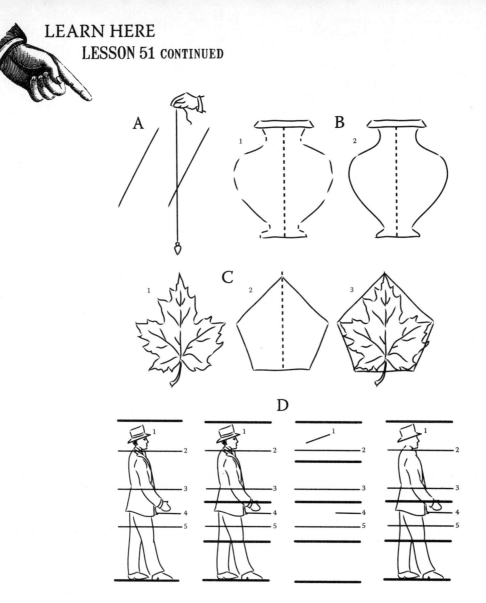

METHODS IN DRAWING GRAPHICALLY EXPLAINED

A By itself, the inclination of an oblique line is hard to perceive. Compare it with a vertical line, then the angle will show the degree of inclination at once. Use a plumb-line.

B The subtleties of curves are better discerned and drawn by first roughing them out with straight lines.

C The shape of a simple plane form is easy to grasp. In drawing anything of an irregular or an intricate contour see what simple form approximates it, or can enclose it. Draw that first.

D A number of spaces of unequal length are hard to get offhand. Equal lengths are much more easily estimated, marked, or drawn. For instance, you want to see where a certain point comes between two other points. Divide the space with your mental eye into half, then see where the point in question comes in relation to the half-way point.

In D (a) lines 1 to 5, inclusive, mark places and divisions that would
 be helpful in starting this sketch, but the divisions are unequal and not determined readily.
 (b) As equidistant measurements are easily discerned, perceived, and obtained, divide the height of
 the figure into four equal parts.
 (c) Now the positions of the lines 1 to 5, inclusive, are quickly fixed, so that:
 (d) You can go on with the sketch.

Do all this mentally; the diagram is only an example to show the concept.

PRACTICE HERE

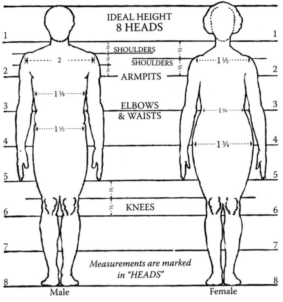

IDEAL HEIGHT
8 HEADS

SHOULDERS
SHOULDERS
ARMPITS
ELBOWS
& WAISTS

KNEES

*Measurements are marked
in "HEADS"*

Male Female

PROPORTIONS OF THE HUMAN FIGURE AND DRAWING WITHOUT MODELS

For practice work from models, or drawing figures without their use, keep in mind a proportional division of the figure for guidance.

The proportions of the artistic scale of the human figure are given in "heads," established by taking the height of the head as a unit and seeing how many times it goes into the whole height of the figure.

Opinions have differed as to the number of heads to use for the perfectly constructed figure. Vitruvius recommends the scale of eight heads, while Vasari and Filarete both said that the human form is better represented by building it on a scale of nine heads.

Some old engravings by Aldegrever show figures that are drawn nearly ten heads high, actually outdoing modern fashion plates, which are rarely taller than nine heads.

The classical proportion of eight heads is the scale in general use; however, figures are more likely to be seven or seven and a half heads. Figures made in these latter proportions look correct; but in idealistic compositions in which dignity, grandeur, or the heroism are expressed, the classical canon of eight heads is better.

Very careful measurements for an ideal human form have been worked out—widths of the calf, the knee, thigh, neck, and so on, but as a rule it is not necessary to bother with such details. That will just confuse you. Trying to remember and to work by minor measurements may prevent the exercise of good judgment and aesthetic sense.

Even if accurate measurements could be taken, the words "approximate" and "about" are always tagged on anyway. The lack of hard fixed points and the nature of muscle and skin make it impossible to get dependable points from which to measure.

PRACTICE HERE

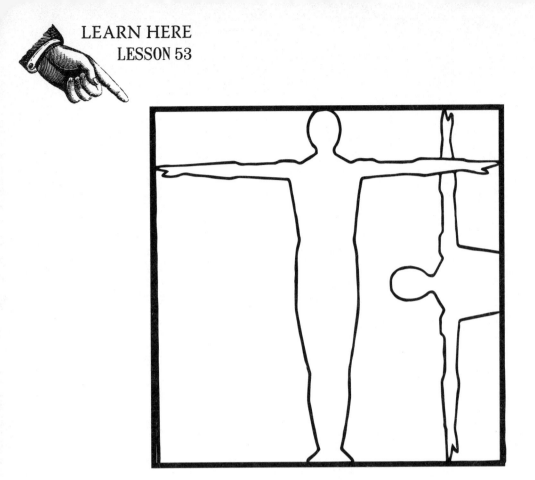

IN AN IDEAL FIGURE THE SPAN OF THE EXTENDED
ARMS AND THE HEIGHT ARE EQUAL

PROPORTIONS AND SYMMETRY IN FIGURES

It is only essential to remember a few general ideas of symmetry, such as:

Entire figure..8
Head and body..4
Lower limbs...4
Leg, top of knee to base of heel ..$2^1/_2$

When the arms are hanging by the side the elbow is on level with the waist, and the tips of the fingers reach to about the middle of the thigh.

The vertical measurements for the female figure are usually calculated as above; the proportions across varying—generally smaller, except for the hips. Here the width is $1^3/_4$ or up to 2 heads.

According to an ideal model of human proportion, the span of a man's extended arms equals his height. This is not often true in nature. The arms are generally too long to comply with this test of physical perfection.

Keeping the above proportions in mind when drawing figures is sound artistic judgment. Minor details such as relative thickness of neck and sizes of hands or feet depend on the subject.

PRACTICE HERE

PROPORTIONS OF THE FEMALE FIGURE IN ACTUAL LIFE AND PICTORIALLY

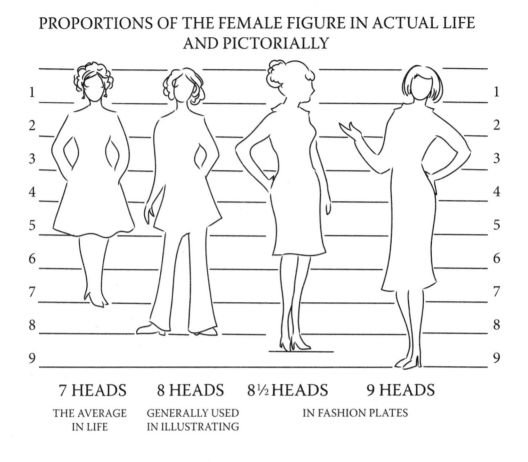

7 HEADS	8 HEADS	8½ HEADS	9 HEADS
THE AVERAGE IN LIFE	GENERALLY USED IN ILLUSTRATING	IN FASHION PLATES	

PROPORTIONS AND DRAWING FIGURES IN ACTION

When drawing with models, keep in mind a relative proportion of head to entire figure. When making what are known as "straight" illustrations, that is, pictures in which models are used and the human form is represented with as much faithfulness as possible to life, the scale of $7^{1}/_{2}$ or 8 heads is common practice.

On the other hand, most of the humorous cartoonists make figures proportioned nothing like the "normal."

Here's how you draw figures in action or "out of one's head":

Make a single line sketch of the desired action with just enough drawing to give the character of the action or movement. Draw an oval-like contour for the head, keeping in mind its relative size to the intended figure height. Then indicate the body, and then suggest the general outline of the muscular form. This, so to speak, is filling out the skeleton action figures with flesh. Finish the drawing by covering the figure with apparel.

PRACTICE HERE

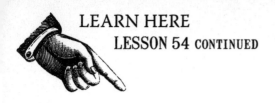

PROGRESSIVE STEPS IN FIGURE DRAWING WITHOUT USING MODELS

PRACTICE HERE

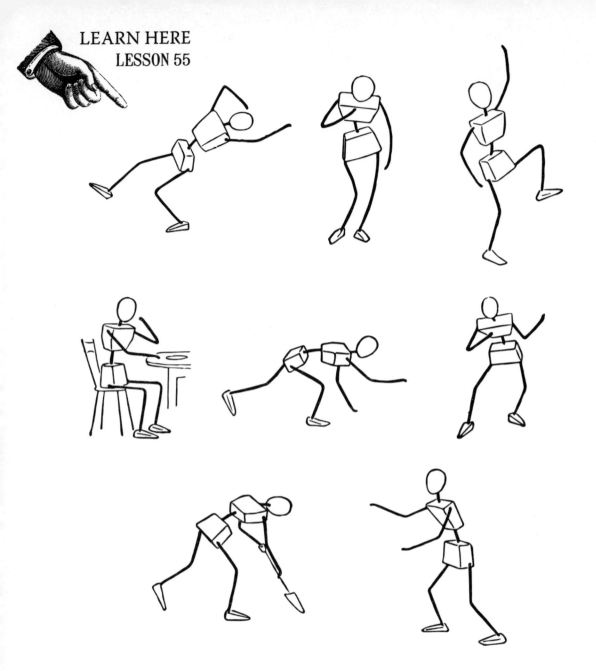

DRAWING WITH MANIKINS

You will note in the diagrams explaining the method in the previous lesson, that the body is shown as a firm, inflexible torso. It is not always that way. You can see in the next image a method which explains a little better how to draw the figure without models. Allowance is made here for the flexibility of the part of the torso between the box-like chest and the box-like hips. The sketches in the image were made with the aid of a little manikin about 12 inches high. The head, chest, etc., were whittled out of wood and joined by pieces of lead wire to represent the limbs, neck, and spine.

It might be helpful to construct one of these manikins; making it will show you the litheness of the human body and the many attitudes it can assume. It will not be of much use as a lay figure to set up and draw, but it may give ideas of unusual poses and actions to be used in cartoon and comic drawings.

PRACTICE HERE

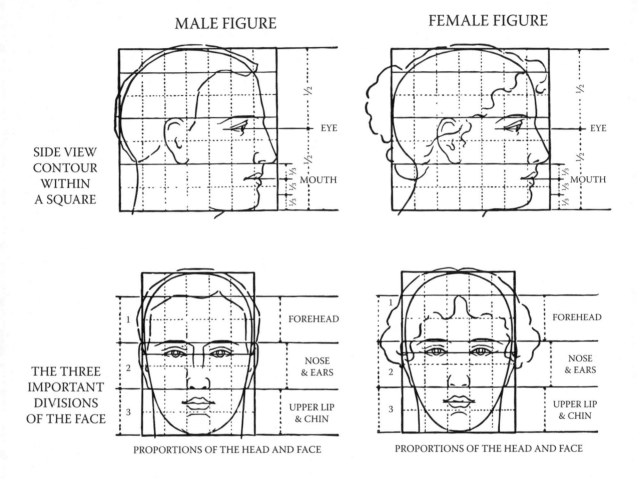

MALE FIGURE

FEMALE FIGURE

SIDE VIEW
CONTOUR
WITHIN
A SQUARE

THE THREE
IMPORTANT
DIVISIONS
OF THE FACE

PROPORTIONS OF THE HEAD AND FACE

PROPORTIONS OF THE HEAD AND FACE

DRAWING FACES AND PROFILES

Moving on to drawing the face and head, these three things should be noted first:

A The axis of the eyes coincides with the center of the space between the top of the head and the bottom of the chin.

B A square encloses the side view of the head.

C The face is divided equally into three parts:

(1) From the roots of the hair to the eyebrows. (2) From the eyebrows to the base of the nose. This division is referred to as the length of the nose, and is sometimes used as a unit of measurement. (3) From the base of the nose to the bottom of the chin.

The above points, A, B, C, along with getting the ears properly placed in relation to the middle division of the face, are important to remember when drawing faces.

PRACTICE HERE

CLASSICAL PROFILES

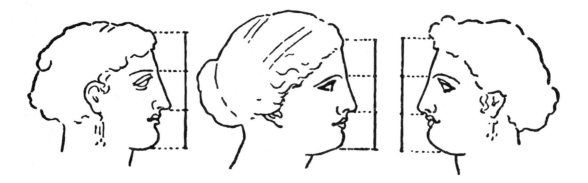

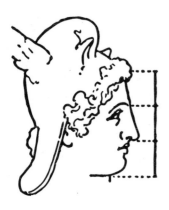

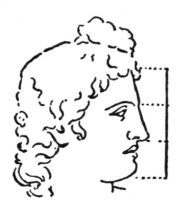

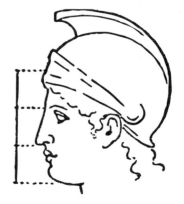

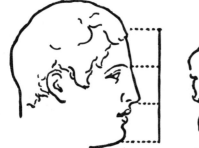

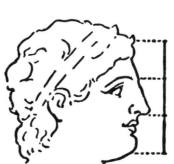

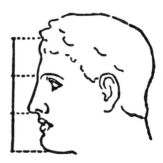

From statuary, reliefs, and coins

PRACTICE HERE

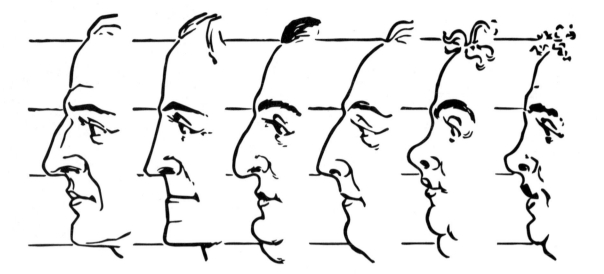

NO MATTER WHAT TYPE OF FACE YOU DRAW, KEEP IN MIND
THE IDEAL DIVISION OF THE FACE INTO THREE EQUAL PARTS.

DIVISION OF THE FACE IN THREE PARTS

If the lower division of the face is divided equally into three, the middle of the mouth comes at the line of the first division, or one-third down. Note this in both front and profile views.

Looked at from the front, the width of an eye, the width between the eyes, and the width of the nostrils are all the same. And this measurement, considered as a unit, is one-seventh the height of the head or about one-fifth its width.

The position of the ear is best understood by considering it in a profile head. It should be placed so that a line from the top of the ear to the eyebrow or the root of the nose is parallel to a line running from the lower edge of the ear to the base of the nose. In other words, the ear is on the same level and is the same length as the nose. These two parallel lines define the middle division of the face as noted above. You will see many exceptions to this rule as you observe, and there will be many that you will not see, since the ear is often hidden by the hair.

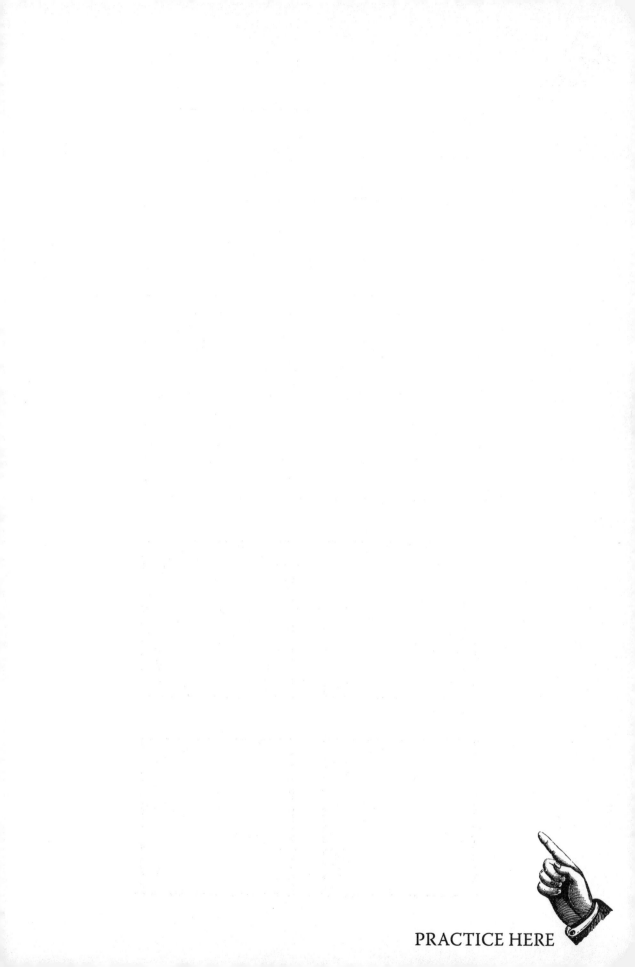

PRACTICE HERE

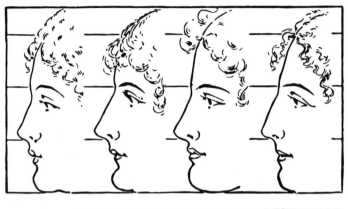

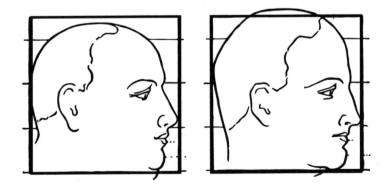

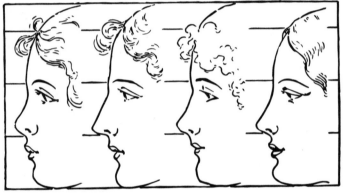

PRACTICE HERE

DIVISIONS OF THE HEAD AND FACE

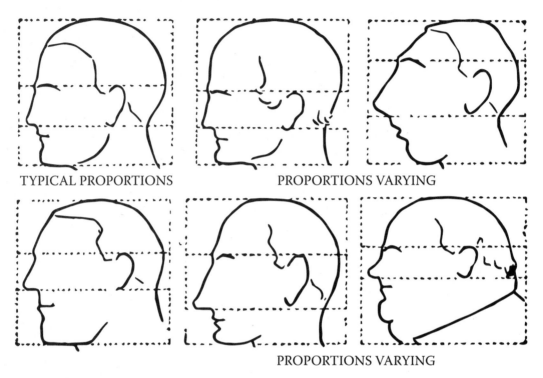

TYPICAL PROPORTIONS PROPORTIONS VARYING

PROPORTIONS VARYING

CONSTRUCTION LINES IN DRAWING

Keeping in mind the previously mentioned symmetrical relationship of features will help when drawing faces, whether with models or without them.

An effective way to draw faces without actual examples before you is to construct them using lines to define the proportions. These guide lines are especially helpful in faces and heads that are drawn in three-quarter views.

Three-quarter view faces are difficult to draw. The American artist, Rembrandt Peale (1778-1860), suggested drawing the features on a hard-boiled egg and then using it as a model for getting a variety of views by turning it around at different angles.

If you have any ability in the plastic art, it might be useful to model a little head for use as a copy. This would be a big help if you were making a series of illustrations (not using models) in which the same character appeared throughout the series.

PRACTICE HERE

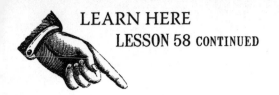

THREE QUARTER VIEW FACES

PRACTICE HERE

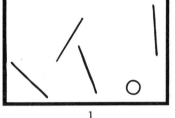

1 2

1 Circle and lines put in haphazardly lack real art interest.
2 Attracts attention at once because it shows that thought was used in the arrangement. But the premise is too evident and leaves nothing to the imagination.

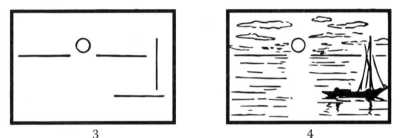

3 4

3 Again thought is exhibited in the disposition of the components. The non-symmetrical arrangement excites interest. There is a hint of mystery there.
4 Simple pictorial composition built on the preceding diagram.

PICTORIAL COMPOSITIONS

The average drawing made for books or newspapers is usually either a descriptive illustration to the text or a character sketch solely put in to relieve the monotonous gray type mass. In the making of these, the principles of pictorial composition are not always used.

This should not be so. It would be better if illustrators gave more attention to the ideas underlying artistic pictorial construction. The rules are not set and prescribed formulas that are to be followed minutely. In fact, the matter might be put in this way: An artist decides on a certain kind of composition, then tries to see how far it can get away from this particular composition, without really losing sight of it as the basic feature of the picture. The artist adheres, in spite of variations and modifications, to the general structural arrangement in mind at the beginning.

Every picture should have some point of interest. Sometimes this point of interest is represented by a spot of light, a note of color, or a figure or group in bold and clean-cut silhouette against the rest of the differently toned picture. Or, again, it may be a face, strong in character or expression, lighted and set off by contrasting tones or background. The point of interest, whatever it may be, together with the other components of the picture, must be arranged so that they form a pleasing unity.

Exactly why one combination of lines, masses of tints, or spots and areas of colors pleases, and another does not, is a difficult question. But it is the function of the theory of pictorial composition to answer it by setting rules and presenting them in an way to help produce pleasing works of art.

PRACTICE HERE

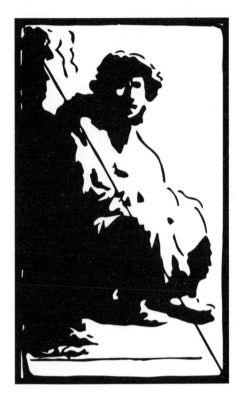 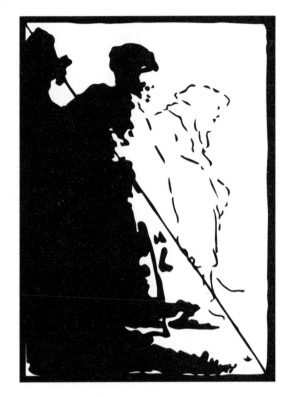

Two of Rembrandt's sketches in which the lights and shadows have been simplified.

DIAGONAL COMPOSITIONS

Seemingly without effort, some artists create effective pieces, but most of us must practice and apply ourselves until we understand the rules of picture composition and the principles of beauty in constructing objects. On examining the work of a talented artist, these qualities are conspicuously in evidence: sincerity, confidence, skilled technique, and throughout the work a thorough mastery of tools and material. These qualities are all essential in a good picture, yet they are not emphasized in a treatise on composition.

As generally understood, good composition means the grouping of different parts of a picture in a geometrical arrangement of lines and spaces.

The simplest type of well-composed picture is diagonal or angular. In this an oblique line separates the space into two triangular areas, one in light and the other dark or in shadow. Now, if the difference between these two contrasting areas was exactly marked along the diagonal, the result would not be a picture. To approach the pictorial, the dark part must be broken up with light, and some of the darker shades must run over or break into the light space.

PRACTICE HERE

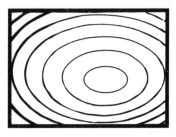

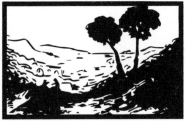

THE BAY OF BAYÆ

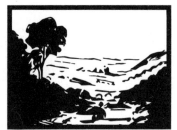

VIEW OF ORIVETO

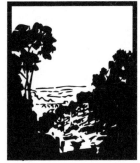

CROSSING
THE BROOK

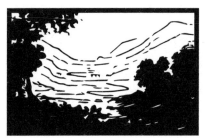

APOLLO AND DAPHNE

COMPOSITIONS OF MASTERS

A knowledge of what constitutes good composition is best gained by observing, studying, and reflecting on the works of the masters. On careful consideration of good pictures you will notice their components are arranged to form some kind of geometrical figure, not completely obvious but noticeable.

The works of Rembrandt are a good example of this. In his paintings and etchings with their effective handling of light and shade are so many lessons on objects. Much may be learned, too, from the wonderful canvases of Turner. Turner had a gift, showing plainly in his work, of creating interesting pictures by building them on certain arrangements of lines. In a work by him, the basic idea or design, though clearly apparent, excites interest, mystifies and holds the viewer's attention by the subtle way the composition is diversified and varied.

Some of Turner's paintings betray a fondness for an arrangement that, if put into a diagram, would be a series of concentric ellipses, the central and smallest holding the point of interest. This inner ellipse is never in the center of the area of the picture but a little below and either to the right or the left of the center.

PRACTICE HERE

ZURBARAN

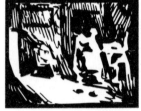

BREKELENKAM

WEENIX

REMBRANDT

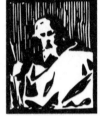

RIBERA

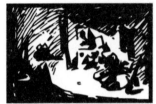

WILLEM KALFF

CUYP

KESSEL

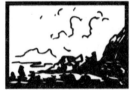

CUYP

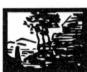

JAN BOTH

VAN DE VELDE

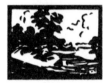

WYNANTS

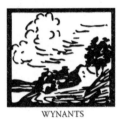

WYNANTS

WYNANTS

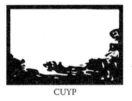

CUYP

MINIATURE SKETCHES

An excellent way to get insight into picture composition is to make miniature sketches when studying the canvases of the masters. Arrange the sketch in simple broad effects of white and black and do not trouble with the details. Making them in ink will be a good test of simplicity. Some works, for instance, that are intricate collections of highly finished costumed figures, do not come out well in this sort of test. You will understand why such works, in spite of all the scrupulous care bestowed upon them, cannot be considered great works of art because they lack one big thing—simplicity.

PRACTICE HERE

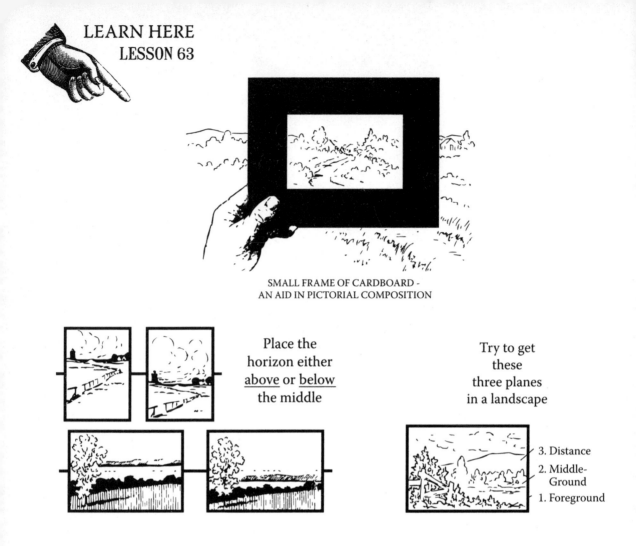

SMALL FRAME OF CARDBOARD -
AN AID IN PICTORIAL COMPOSITION

Place the
horizon either
<u>above</u> or <u>below</u>
the middle

Try to get
these
three planes
in a landscape

3. Distance
2. Middle-
Ground
1. Foreground

SKETCHING FROM NATURE

When sketching from nature—pencil, watercolor, or oil—carry in your kit a little viewfinder of cardboard to help you choose well-composed bits of landscape. It is easily made using a frame of cardboard with the opening a rectangle of the same size as your canvas or sketchbook page. The cardboard should be of a dark tint, or blackened with ink.

Hold this little frame between the eye and the view and move it along until it encompasses a section of the landscape you like. Many unexpected pictorial effects are found using this little contrivance.

Using this viewfinder also enables the sketcher to fix the place of an important item in a landscape: the horizon. In landscape sketch the horizon should either be above or below the middle of the picture. That is, the particular shape that you have decided on for the picture must not be divided into two equal parts by the horizon.

According to some artists every landscape to be considered artistically put together should have these three planes, not necessarily obvious but discernible, marked:

(1) foreground, (2) middle ground, (3) distance.

PRACTICE HERE